PENGUIN BOOKS

THE HIGH WEST

Wildlife photographer Les Blacklock's interest in the mountains, initiated during a boyhood vacation trip, was confirmed by his experience as a ski instructor and mountain-climber in the 10th Mountain Division during World War II; in the years since, he has spent much of his time camping and photographing in the spectacular wild country of the western United States and Canada. At his home in Eden Prairie, Minnesota, he prepares for wide-ranging trips to make still photographs for books, magazines, advertisements, and calendars, and to create wildlife films that are distributed nationally. Between expeditions he speaks to students and adult audiences about his adventures and about man's relationship to the earth. Les Blacklock is a consultant to organizations and agencies, advising them on ways to preserve the wildlife habitat in camps, parks, and nature centers. He is also co-author, with Sigurd Olson, of *The Hidden Forest*.

Writer and rancher Andy Russell has been a bronco-buster, trapper, cowboy, and wilderness guide; he is also a photographer, lecturer, and radio broadcaster, and at present is a contracting environmentalist. Born and raised in Alberta, Canada, he has spent most of his life in high country on both sides of the border and has organized and led eight expeditions into the Canadian North and the Arctic. More than one hundred of Russell's articles and stories have appeared in *Reader's Digest*, *True*, and leading nature and wildlife magazines. He is also the author of *Grizzly Country*, *Trails of a Wilderness Wanderer*, and *Horns in the High Country*.

THE HIGH WEST

Photographs by Les Blacklock

Text by Andy Russell

PENGUIN BOOKS

To the memory of Olaus Murie
our friend and an immortal whose
encouragement and dedication to wilderness
served as an inspiration to so many

Penguin Books Ltd, Harmondsworth, Middlesex, England
Penguin Books, 625 Madison Avenue, New York, New York 10022, U.S.A.
Penguin Books Australia Ltd, Ringwood, Victoria, Australia
Penguin Books Canada Ltd, 41 Steelcase Road West, Markham, Ontario, Canada
Penguin Books (N.Z.) Ltd, 182–190 Wairau Road, Auckland 10, New Zealand

First published in the United States of America by The Viking Press 1974
Published in Canada by The Macmillan Company of Canada Limited 1974
Published in Penguin Books 1976

Text Copyright © Andy Russell & Sons Productions Ltd., 1974
Photographs Copyright © Les Blacklock, 1974
All rights reserved

ISBN 0 14 00.4425 6

Printed in the United States of America by
Kingsport Press, Inc., Kingsport, Tennessee
Set in Weiss

Acknowledgment is made to Dodd, Mead & Company and McGraw-Hill Ryerson Limited for lines from:
"The Ballad of the Northern Lights" by Robert W. Service.
Reprinted by permission.

CONTENTS

INTRODUCTION

The spirit of the high and wild country of the West is very powerful—big medicine, the Indians call it. Those of us who have spent our lives working in the midst of it every day know its influence and its beauty. We who strive to interpret and portray it for less fortunate ones living in the concrete canyons of big cities and the sprawl of adjoining suburbs are charged with the great challenge and responsibility of helping them to know it better and to realize that the richness of this wild country is worth preserving, even though they may never see it.

We are also aware of our limitations with words and pictures. No matter how skilled we may be, we cannot match the throbbing life, the magnificent panoramas, and the intangible qualities of the many faces and moods of the mountains.

A winter storm in high country, when temperatures run below zero, when the wind drops the chill down to levels almost beyond endurance, and flying snow cuts one's face like a knife, has to be experienced to be appreciated. It is then that the real values of life rear their heads and make themselves known. To grasp them and to use them means survival; to fail to adjust means death. It is then that man meets himself as what he really is: another of nature's warm-blooded creatures fighting to stay alive. The experience can be stark and cruel, but it is a telling introduction to nature to be where even the willows of the high alpine slopes and the northern tundra must condition themselves to survive by remaining small, clinging close to the surface of the ever-sheltering earth. There are times when nature is merciless, but it is also always dramatic and beautiful when seen through the windows of perceptive vision and imprinted on an open mind.

I recall a day when the conditions were about as bad as they could get. My trail led me across a steep, unsheltered mountain slope where the wind was blowing up a ground storm so thick at times that I could not even see my feet for flying snow. The powdery crystals were blinding and drove into every crevice of my clothing, cutting my face like fine sand. The wind chill was somewhere near seventy-five or eighty degrees below zero. It was a white hell where a man knows he dares not linger long or make a mistake in his choice of footing, or he will perish miserably.

Then the sun broke through the leaden overcast, lighting up the rock faces overhead in weird outlines weaving in the driving gusts. And there only a few yards away stood a great bighorn ram among the whirling, dancing snow devils cavorting in the lee of a cliff. He gazed at me curiously, completely impervious to elements I thought sufficient to drive anything to cover. The sight of him warmed my heart and left me with a never-to-be-forgotten picture illustrating a power of endurance most of us never know.

It takes endurance to live with the wild ones, discovering some of the unknowns concerned with their lives so that we may picture and interpret them. The experience brings us back to the basic fundamentals of man's true association as a part of nature. It illustrates in a most graphic way the fact that if man is to survive as a species on the face of the earth, he must not only know his limitations but also come to understand them. In spite of himself, he cannot be separated from nature. He is not a god above its power, and his true place is as an entity with it, and not as a continual destructive usurper or intruder with no feelings for its spirit.

You feel that spirit when you stand in an aspen park among foothills couched at the feet of the Rockies, the high soprano of a coyote's song ringing in your ears and the golden light of autumn pouring down through the leaves. You come to know it a little on an iron-cold arctic night with stars shining overhead and the timber wolves tuning up their long-drawn ululation under the pale arch of northern lights. The sheer beauty of it settles permanently into your bones when you stand on a clear morning watching bull moose parade through a pond accompanied by their majestic reflections on its mirror surface. You come to love it when you let yourself be a part of it, no matter where you live and regardless of your opportunity to know its more exotic forms.

It is a matter of training the eye to see what nature contrives every day around us. To watch a spider weaving its lovely trap to catch a fly for breakfast is a revelation. To examine through a magnifying glass a raindrop clinging to that web and see a wildflower reflected in the lens is a glimpse into nature's never-ending art. Some of it can be captured on film; some of it one can only imprint on the mind.

But some portions of it can be found in your back yard or on the printed pages of a book opened in front of your evening fire. So join Les Blacklock and me on this trail—a path unwinding through wilderness country among shining mountains, across their vigorous slopes, down adjoining valleys and through warm meadows where wildflowers dance in the wind. It is a way interwoven in a vibrant tapestry of life in wild places—of all that goes to make up the high West.

MOUNTAIN STREAMS

The song of wild mountain country is carried by tumbling waters running boisterous and free down rough wind- and ice-carved slopes on the first tumultuous bounds of their journey to the sea. The lyrics vary from full-throated roaring of river falls to the merry chuckling and tinkling of tiny rills, sometimes hidden and then revealed among the rocks. Springs bubble from secret reservoirs concealed in the sedimentary stone, leaping gaily, natural fountains playing in the sun among brilliant mountain flowers. Inevitably the small streams gather together to make creeks, and these follow the same pattern to form rivers winding like silver-blue ribbons down between cathedral groves of timber.

In the old days the Indians listened to the singing of the waters, and it was good. The streams were happy, they said, as they gathered across the face of the living earth; it was the marriage of the water, sun, and soil, making all life possible. Flowers and grass grew among the great trees beside them, joining with the wind to add their voices to the chorus. The Indians knew they were a part of it along with the buffalo, antelope, wild sheep, and deer they hunted. The sun was the great spirit, the earth was the mother, and the water was the juice that flowed between. For was it not the sun that brought rain, warmed the earth, and caused the winter snow to melt? To the Indians it was very simple to understand. They drank of the waters, bathed in them to cleanse themselves, worshiped the sun, and thus were a part of the pattern of life on the face of the earth. Because of the abundance of other life on the plains in front of the mountains and in the great valleys between the ranges, they were hunters.

The first white men who came working their way upstream from the east were hunters too. They came by boat till the streams became too small and swift, then they went on horseback and on foot up along the creeks in search of beaver. The beaver were so thick in many places that they choked the creeks with dams, laying one above the other like steps woven of mud and sticks, with ponds between. There the trappers, with old moccasins covering their feet, and with their buckskin leggings shortened to the knee, waded as they set their traps, cursing the icy water, and the only part of them that got bathed, short of accident, was their feet and legs. But they kept up the relentless search for skins, piling up the pelts till the beaver had all but disappeared.

The trappers were a breed set apart by their chosen environment, and they looked with some contempt and a reluctant awareness on the change in their wild free ways that came as white settlers wound

their way slowly west by ox team and covered wagon, across the folds of great plains lifting and falling under their wheels like swells in a sea of grass. Buffeted by storms, sometimes attacked by hostile Indians or held back by the distances, they forded rivers and smaller streams, cursing when their wagons and stock bogged in quicksand and wheels broke on the steep, rocky pitches of the banks. Sometimes men and animals drowned in the swift waters, but others fought their way on west, following their destiny toward a promised land of riches somewhere yonder beneath the setting sun.

When they came to deserts, they fought their way across them, too; no detours for them, no bending to the forces of nature; it was fight and fight some more—defeat the wilderness—every step of the way, while the pitiless sun shone down and the shining sand was like the floor of a red-hot oven. There were no waters singing here, and many died of thirst.

One group had come West to escape persecution in the Eastern settlements. The Saints, they called themselves; their leader was Brigham Young and their guide the famed Jim Bridger, mountain man turned trader and guide for these wagon trains. He brought the Saints to a huge, wild, and inhospitable basin between the mountain ranges overlooking the glistening reaches of Great Salt Lake and stopped. He sat his horse, with the long fringes of his greasy buckskins stirring slightly in the hot wind. Taciturn for the moment, he silently contemplated these travel-worn, sun-scorched, but grimly determined people who had followed him to this place. Out of long ingrained habit, his eyes were on the move, making note of every detail near and far, reading things completely hidden to the others, signs as lightly written as the soft brush of owl feathers in the dust, where the bird had taken a desert mouse. His gaze swept out across the dry, parched earth past a lone cottonwood tree to the distant blue sheen of the lake so salty a fresh egg would float on it, then swung back up a watercourse along a river in a valley debouching from the mountains back of the wagons. Even the river lost itself in the sand and gravel beds before it reached the lake. It was tough, inhospitable country, where roving Indians did not tarry long.

Why would these people want to settle here? Brigham Young had answered that question by stating it was his instruction from God; they would settle in this spot because it was far enough away and hard enough to reach so that nobody else would want it. How would they stay alive? They would use the streams coming down from the mountains to irrigate this land and bring it to life. The mountain man reputedly scoffed at that and offered the Mormon leader one thousand dollars for the first bushel of corn grown in this place. But Bridger had not reckoned with the know-how of these people or with their determination. For in due course they harvested their first crop of corn. History does not record if Brigham Young was ever paid, but the recollection of Jim Bridger's offer amused him and he was fond of telling about it in the years that followed.

Apart from the Spanish settlements in California, where irrigation had been used in the previous century, and some early efforts of farmers and ranchers in the plains of northeastern Colorado, this

was perhaps the first time settlers utilized the streams in western North America on such a scale. But they and the horde of settlers to follow thought of water as something put there for man to use. They did not relate its presence to the life it supported in this great new land, for their fight to stay alive in the wilderness had become an ingrained thing, a characteristic still evident in our use of resources, and one that has proved to be shortsighted and very wasteful. Too many have looked on the great trees growing in the valleys and along the flanks of the mountains, their roots set deep in the water-moistened earth, as only something to be cut into planks and boards. They have not paused to see the beauty. If any of those early settlers loved the streams purely for their freshness and beauty, it was the children who played beside the crystal-clear cold water, fished for trout, and swam in them. They heard and began to understand the song.

Up along the foot of the Canadian Rockies I grew up on a ranch on the edge of the frontier, exploring and fishing the creeks. One of them I came to think of as being mine. It was the Drywood, and it nurtured me.

We lived on a bench in a comfortable home overlooking the forks where the creek swept down past the rugged flanks of Drywood Mountain, which stood with its great shoulders lifted in a never-ending shrug of patience with time, the elements, and the vagaries of men. The clear, icy water provided me with a playground—a place to fish for the softly colored cutthroat and Dolly Varden trout and to swim in its deep pools. I left tracks on the sandbars with those of deer, bear, beaver, mink, and many other wild creatures, large and small, which shared their secrets with me, each of us adding a sentence to this story of the wilds. It was there on the edge of a beaver pond, by the gnarled feet of some giant cottonwoods, that I met my first grizzly face to face. The great bear towered at full height over me while I stood frozen in my tracks, scared, small, and very much impressed by this huge beast which chose to turn and leave without a hostile move.

It was there I heard and listened to the song telling me of the mysteries of life supported by this stream; life that ranged from the tiniest of larvae to great Dolly Varden trout as long as my leg, the one dependent on the other. For I caught the Dolly Varden and learned from looking in the stomachs of the smaller fish in its belly that my feeding on its delicious pink flesh had started with caddis larvae, freshwater shrimp, and other bugs eaten by the trout's prey, all forming a part of the mysterious and intricately woven life pattern of the creek.

In winter the creek ran under ice frozen on its surface; then my tracks mingled with those of the things I hunted while the water murmured sleepily in its bed, shackled by the elements. Sometimes storms tore at the trees growing along its banks. In spring the ice thawed, and the creek roared with boisterous delight at being free and fed copiously on the runoff from melting snow. Then it was dangerous to fawns, cub bears, and small boys. Sometimes tragedy struck among the snags and rocks, where the fierce waters flung manes of spray into the air and roared with utter savagery. In summer it

11

was serene and lovely, harboring hordes of tiny fish fresh hatched from its colorful gravel beds, feeding them the minute things needed in their struggle to grow big enough for boys to catch. In the process some of them in turn fed the great Dolly Vardens.

All life is wonderful and beautiful, said the song, and to the boy, watching sometimes in awe and listening to its music, wondering and waiting for what would happen next, a day seemed short. Time was something that began when the sun came up and ended when he fell asleep. To the stream and its foster parent, the mountain, time was as endless as its patience with all things—the fierce storms, the wind, heat, and cold. But there was no way of accounting for the ambitions of men who had never heard the song.

One day they came—men who had no feeling for what it means to live on the face of the land and be part of it, relating to the life patterns there. They knew only how to tear riches from it, leaving scars that could never heal—festering, scrofulous scars. They neither knew nor cared about the virtue and rewards of patience; otherwise they could have taken what they wanted without leaving hideous marks along their trails. They drilled holes down past millennia of rock, two miles or more toward the very heart of the earth, and there found residues of things long dead. They hurried, breathing hard in their excitement, for this was gold—black gold—poison gold laden with sulphur, the smell of hades, gases and minerals to throw away or offer on the marketplaces of the world. In their tearing hurry to refine the valuables they had no time for caution. They took what they wanted, released the stink to putrify and poison the air, and poured deadly effluents into Drywood Creek. These killed every living thing within its waters for miles, even the old trees I had known along its banks. They transformed the stream from a thing of wondrous beauty into a twisted, tortured wreck as dead and lifeless as the body of a snake rotting in the sun. Even a dead snake supports some kinds of life, but the creek now supported nothing except a gray-green algae that turned the colored rocks in its bed into featureless lumps of slime.

It is dead, this stream—as dead as anything can be and still have hope of being restored to life. As it stands, there is no way this can be done, for there is nothing in it for anything to eat; the once pure waters stink.

Can the Drywood and others like it be revived? It is a question of how soon we learn to care and understand and how much we are willing to pay. The price of such carelessness is high. But there is really no choice. If we can claim the intelligence to create our technocracy, we must also find the way to manage it and repair the damages, thus returning the dead to the living, restoring the wasted waters so they again belong to nature—a place where trout swim and bright-hued dragonflies dip and dance on delicate wings as a prelude to laying their eggs.

Only then will the song resume.

WINGS OVER THE MOUNTAINS

We had been climbing all day, reveling in the keen, clear air and the challenge of pitting our wits and leg muscles against steep rock. Not just one but two peaks were behind us where the mountains pitch tall and craggy on the west slope of the Continental Divide, and our tortuous trail had kept us high above timberline since sunrise.

Now we were tired—bone weary is the better term for it—as we stood on the rim of a cliff overlooking the valley where our tent was pitched five thousand vertical feet below the soles of our climbing boots. My partner and I stood looking down, silently wondering if we had enough steam left in our frames to reach it, and knowing that if we didn't it was going to be a long, cold, hungry night without sleeping bags or grub—a siwash camp where one covers an empty belly with a tired back. The sun rolled below the horizon to the west, leaving a rosy halo in the clear sky along a rim of jagged skyline fifty miles away. It was an evening without a breath of wind, the silent hush of twilight dropping around us like a soft blanket.

Then came an electrifying sound, faint and faraway, of wild geese calling, and we lifted our eyes to see two great ragged Vs of snow geese heading southwest overhead. They were high enough to be still in the sun, their white feathers looking rosy pink against the blue of the sky, and their wings heliographing in time with their steady beat. We stood there a mile and a half above sea level, with the geese another five thousand feet over our heads as they winged their way down across the Rocky Mountain flyway on their journey to California and Mexico for the winter. These were the leaders of the legions to follow, birds which had hatched down on the oozy tundra of Canada's cold north rim where the great barren lands slope into the sea, or out on the arctic islands beyond. Now they were a

bit more than half way on their four-thousand-mile journey to the balmy climate of their wintering grounds.

Just seeing them was exhilarating, and as we climbed swiftly down the steep pitches toward camp, racing the night to a hot supper and warm sleeping robes, I was thinking of these birds and marveling at their spectacular and unerring navigation of this flyway. One does not ordinarily look at mountains cleaving the sky with waterfowl in mind, but here they are at times during their migratory passage, sometimes flying in perfect weather like this, but more often beating their way through turbulent storms.

The greater part of their kind swing east and south from the northern nesting grounds to go along the Mississippi and Atlantic flyways, but a good portion of them choose this sky road—a flight line crossing the Rockies near the 49th parallel. It is a spectacular flyway shared by hundreds of thousands of other migrants: Canada geese, whistling swans, mallards, pintails, gadwalls, goldeneyes, bluebills, and even the dusky-colored coots, to name a part. Following the nesting season and molt, all these gather into great flocks across the parklands and prairies. The snow geese come from farthest north, winging south on the breath of the first cold blast of arctic storms heralding the coming of winter, and they gather on the larger lakes in thousands.

There they mingle with other wildfowl that have learned to glean grain from the stubble of wheat and barley fields—the Canada geese, mallards, and pintails, all fattening on the rich food. It is a dramatic pause, for each day they fly a gauntlet of guns in hidden blinds deceptively surrounded by various kinds of decoys set out to lure the birds within range—subterfuges sometimes astonishingly elaborate, contrived by men caught in the spell and excitement of the sound of whistling wings. Though they kill the birds, they love them, a love well illustrated, for it was at their insistence that an international law was passed back in the dried-out hungry 1930s to save the birds from extinction and insure the continued flight of these feathered travelers down the length of the continent. Since then the hunters themselves have dipped deep in their pockets every year for the money to reclaim wetlands, improve nesting grounds, and provide protection.

On down the plains on the eastern side of the Rockies the birds slowly make their way from one choice feeding ground to another. The slough ducks, such as teal, spoonbills, and gadwalls, join the divers—the redheads, scaup, goldeneyes, and others of their kind—in the procession south. Then the pintails—Hollywood mallards, as some hunters call them—take their leave. Only the mallards and geese linger as the smaller lakes freeze over. As colder weather begins to clamp down, thousands gather overnight on Waterton Lakes for a rest before they take the high flight across the mountains.

Because these lakes are protected by the boundaries of a national park, the guns no longer boom, but feathered and furred hunters are on the prowl. Very early one morning I came out onto a point near

the mouth of the river at the top of the lower lake. In the darkness I felt my way out through a stand of willows into a natural blind among the weather-bleached roots of a couple of big old cottonwoods washed up and stranded here in a previous spring flood. It was still and frosty as I readied my camera on the tripod and made myself as comfortable as possible to wait for light, listening all the while to the gabbling of geese and ducks directly in front of me along the silty shore of the lake.

As dawn began to break, some of the birds became visible, resting on the water amid wraiths of rising mist that lay close to the surface. Beyond the lake a snow-streaked mountain slanted down over a steep slope of yellow grass to a golden footstool of aspen-covered bluffs. The birds and I shared a scene of utter serenity, but we were not alone.

Directly in front of me on the tip of a sandspit jutting a few yards out into the lake a dozen honkers were resting, big and black against the silvery surface of the water. Between us in a scattering of little willows and grass something moved. As first I could not make it out, but a cautious peek through the binoculars revealed a big gray coyote crouched as still as a stone image, calculating the next move that would put him within charging distance of the geese. So well did his coat blend with the surroundings that I could blink my eyes and lose sight of him—a kind of visual sleight-of-hand that made me wonder if the light was playing tricks. Here was drama in the making if the action would only wait until the light got strong enough to expose film. My fingers shook a little as my hand slid toward the camera trigger. But it was not to be.

From behind me a trio of mallards came flying down the river through a corridor of big cottonwoods. They swung, set their flaps, and swooped down so close overhead that I could almost feel the wind off them. The sudden swoosh of feathers caused the coyote to move, and the motion caught the keen eye of a goose. The big bird stretched its neck, gave a low honk, and then, as though at command, all the geese just walked into the lake and swam away. The expression of undiluted chagrin on the coyote's countenance almost made me chuckle aloud. By sheer chance the ducks had robbed us both.

Another day I stood in a grove of scattered snow-draped aspens watching a flock of Canada geese flying toward me at a thousand-foot altitude. It was an undulating formation of no particular pattern, for the birds just seemed to be winging along with no destination in mind, loafing carefree on the air currents.

Suddenly, from far above, a golden eagle swooped down like a feathered spear hurled by angry gods. It struck one of the geese with such force that the air around it was filled with a great burst of feathers, and the hapless bird came down to earth dead as a stone. The eagle followed it and proceeded to feed on it where it fell, for it was far too heavy to be carried away.

The lives of the wild flocks are full of drama, often with tragedy darkening the picture of an otherwise idyllic life of changing scenes and great freedom. For here are birds whose ranges stretch across

thousands of miles of tundra, prairie, and mountains, the pattern of their lives changing with the seasons as they follow their destinies back and forth between arctic barrens and warm subtropics.

Yet their lives are not without moments of natural comedy wrought by the circumstance of the moment—some unusual condition not normally encountered.

On a clear, windless morning following a short, sharp freeze, the water of the lakes above the outlet of the river was frozen in a skim of ice as clear as plate glass. A hundred yards out in the lake there was an open hole completely crammed with mallards sitting in the water and on the ice around it. A few yards beyond them a small flock of Canada geese were resting with a lone whistling swan among them.

I was sitting with my glasses glued to my eyes, watching these birds, when the bugle of a swan drew my attention to a flock of these big white birds flying at low altitude up the river.

Whistling swans are birds of beauty and immense dignity, much taller and heavier than almost any other wildfowl—their size and beauty are equaled only by the much rarer trumpeter swans they closely resemble. Indeed, they look so proud and dignified in comparison to other birds that one is reminded of slightly stuffy society types, very class-conscious and somewhat impressed by their own fine feathers. These are the aristocrats, and they appear to know it.

The approaching flock of a dozen birds came within sight of the ducks and geese and honked a couple of times, a call that was immediately answered by the lone member of their own kind. They began sloping down for a landing, setting their feet and wings for a touchdown a few yards short of the ducks, apparently not realizing that they were dealing with glare ice. What followed was an absolutely hilarious burlesque of what was intended to be a dignified and graceful landing. The instant their feet touched the ice, they were transformed from a group of decorous and elegant birds into a bunch of ridiculous clowns completely out of control. One of them tried to abort the landing with a great thrashing of wings, but it was too late; its feet slid forward past its beak and it went over backwards, with feet paddling futilely in the air. The rest ground-looped and scrambled, flapping their wings and scratching desperately to check their speed, folding themselves together and then unfolding in a wild spectacle of lost balance. Half of them went plowing into the ducks, causing a great burst of flapping wings and startled quacks. The rest ended up strung out raggedly across the ice, gingerly coming to their feet and trying to regain their composure. While various birds sorted themselves out, the geese and the first swan looked on unmoved, but I wondered if they, too, had not landed earlier in the same unexpected fashion.

Sometimes on a clear day after this kind of cold, sharp storm it is possible to lie back with binoculars trained on the sky and see three distinct layers of migrants flying in three directions at this eastern takeoff point of the mountain crossing. The lower layer will be sloping in to land and rest on the lakes. Not all of these birds cross the mountains here, and the middle layer will be heading directly south

16

past the projecting tip of the Great Lewis Overthrust, where Chief Mountain stands looking out across the prairie. These flights point toward the headwaters of the Missouri and a mountain crossing farther south. The top formations, thousands of feet up, will be headed in nonstop flight southwest over the Continental Divide.

It is seeing the sky full of warm-blooded life, all headed for the same general destination by different routes, that makes one's spirit soar, sharing in imagination the adventure and grandeur of migration.

RELATIVE TO RICHES

On the edge of a meadow, alone with three coyotes and a mountain, I stood by a frozen beaver pond. Up on the rim of the peak at the head of the creek January frost and new snow glittered in the dying rays of the sun, but down in the valley the light had turned somber gray. A bite in the breeze made me hunker down into the warmth of my jacket collar. A hundred yards away the coyotes were going through a patch of heavy grass like a trio of pickpockets. They were hunting mice, taking their time about it and treading softly, alert and listening. Now and again one would freeze and then pounce, with front paws held closely together on something rustling in the grass. With infinite finesse born of long practice, the coyote would extract the mouse from where it was trapped, then chew and swallow it. So went the hunt until the whole grass patch had been worked out.

Two coyotes came together and touched noses, and perhaps as a signal of approval for an idea expressed, one of them pointed its nose to the sky and howled a long-drawn song—a salute that the mountain answered with an echo. The coyote had just finished its wild paean when another joined in, then the third, until the whole valley rang and echoed. The trio wound up their cantata with a yapping chorus, a tricky blending of voices sounding like three times as many—fierce, wild sounds telling of the chill, the coming night, and a unique kind of freedom. Then all three trotted away to lose themselves like wraiths of smoke among the willows, leaving a profound silence between me and the mountain.

Coyotes are innovative, enterprising, and exceedingly cunning hunters. On my way home while the first pale stars were showing overhead, I thought about them, remembering times when their playfulness, intelligence, and cruelty had been demonstrated.

From the top of a rocky bluff overlooking an open slope below, I once saw four coyotes come streaking out of a grove of aspens. The leader was carrying a dead magpie, and the others were pursuing in a sort of tag game. Suddenly the bird carrier threw it high in the air, and another picked it up, to be in turn pursued. Back and forth and around and around they went, making the snow fly on their quick turns, until finally their enthusiasm ran out and they just stood looking at one another, panting in the warm sun.

I recalled a frosty morning in late fall when I trotted a bush trail on the way back to school after a weekend holiday. The trail passed a willow-ringed slough, and an old emaciated cow was bogged deep in the muck along its edge. A day or two before, she had walked out on the frozen mud for a drink, but the ice had thwarted her, and when she turned to come back, the frozen crust had broken under her, letting her down in the soft stuff underneath, trapped and helpless, unable to move an inch. Sometime during the night before, the coyotes had found her. Unable to kill her or even tear her tough hide, they had improvised by coming up close behind her to eat their way into her pelvic aperture. When I came, she was still incredibly alive. Her owner was duly summoned, and he put a merciful end to her suffering with a bullet through the head, softly cursing coyotes all the while. Right then I felt that all coyotes should be killed on sight, but as the years passed and my experience grew with me, I came to know that all nature is starkly cruel at times and that this is also a trait of men. The little gray yodeler is a part of the wilds where hunters and hunted contest, and in this I too am responsible.

For many winters I pursued coyotes for their pelts, with rifle, traps, snares, and sometimes hounds. Because some coyotes develop a taste for sheep and poultry, a few of my neighbors resorted to poison. This is a method with no conscience, for poison plays no favorites, killing anything that happens to eat it. It is a means of control I have hated ever since a favorite collie came staggering home, glassy-eyed and retching, to die miserably in convulsions, begging for help we could not give.

Finally the killing palled on me completely, and I found myself watching and admiring this animal which had foiled me so many times and had also managed to survive everything man had contrived to wipe it out. It is amazing how versatile coyotes are when it comes to finding food; only a small percentage learn to kill poultry and sheep.

On a fine October day my wife and I watched four coyotes as they stalked and caught grasshoppers. I have seen them picking and eating saskatoons and huckleberries when the fruit was hanging lush and ripe on the bushes. But they are basically hunters, and there are times in the hard days of winter when they go in small packs after deer. Sometimes they are not successful, but if the snow is deep and crusted enough to carry their weight but lets the deer down belly deep, the killing can be frequent and bloody. It is nature's way of trimming the deer herds to fit the life-sustaining capacity of limited winter feed.

A hunting pair will sometimes relay a jackrabbit—one hiding while the other runs the prey in a wide circle—and when the big hare passes close by, the hidden one takes over, allowing its mate to rest. I once saw two coyotes course a jack around a butte on the prairie, and after they had taken turns, running the hare for a mile or so, both coyotes joined in a final dash for dinner. When the lead coyote drew close to the frantic animal, it made a lightning-fast dodge of sheer desperation, a long twisting jump back over the nearer pursuer. But it landed squarely under the nose of the second one and was dead in the wink of an eye.

20

Though formidably armed, neither the skunk nor the porcupine is safe from a hungry coyote. It will brave the frightful stench of a skunk, picking it up and shaking it to death in a horrible halo of its spray, and then eat it with enthusiasm. Almost every coyote, eager for action on its first hunts, runs into a porcupine and gets a painful lesson, but occasionally a mated pair learns how to handle the quilly creature safely.

One spring evening at greening-up time I was sitting with binoculars trained on a porcupine feeding on new grass out in the middle of a meadow. Two coyotes suddenly appeared on the edge of some thick-growing aspens beyond, and it was evident that they had spotted the porcupine too. Very businesslike, they trotted out toward the unsuspecting animal, but when they came within range of its short-sighted eyes, it swung around, presenting its heavily armed back and tail. With its head tucked in close to its front feet, it looked like a quilly ball fringed with yellow hair.

The coyotes were not impressed, for the male split away from his mate to circle the porcupine. This put the unfortunate animal in a quandary, for in no way could it keep its back to two animals at once, and it spun around, frantically switching its tail. With perfect timing, the male shot in close, flicked his jaws low to the ground to grab the porcupine by the nose, then threw it flat on its back right in front of the female. She clamped down on its unprotected belly, killing it in a few seconds. Both animals fed until there was nothing left but the hide lying flesh side up on the ground. As they turned to leave, the male went to a little cinquefoil shrub and cocked his leg, then turned to make arrogant scratches with his hind feet, throwing dead grass over the shrub, thus endorsing his calling card.

The female was heavy with young, and a couple of weeks later I found their den. Curious to see the pups, I did not approach too closely, for to do so would have caused the parents to move their family to a new location. One evening after a shower, when the sun was warm on the slope, I finally saw all four pups out of the den. It was probably their first adventure out in the bright new world, for they were still small, and quite wobbly on their legs. The female sat looking on while they ventured a few steps this way and that, nuzzling each other and falling over their feet. Finally they found their father curled up asleep among some yellow Indian turnip flowers a bit down the slope and crawled all over him in a squirming heap. He woke but did not move, obviously enjoying their attention. One of the parents at last must have given some signal inaudible to me, for the pups all scrambled back to the den and disappeared. A few seconds later both parents got to their feet, stretched, and trotted away for some hunting.

Ground squirrels and young snowshoe hares were the major prey of this pair as the pups grew and flourished. Now the pups were outside the den much of the time, and the grass and other herbage around its mouth were flattened from their rolling and romping. When one of the old coyotes showed up with some food, the play routine changed in a flash to one of fierce competition that was equally

comical, for they would grab hold of a squirrel or a hare all at once, tugging and hauling in every direction until it was reduced to little but a memory.

The male coyote was a specialist at catching ground squirrels—his technique usually flawless, to a point bordering on art. There were hundreds of these animals on the flats along the creek below the den—easy pickings, it would seem, but each squirrel had two sharp eyes and a penetrating squeaking whistle to warn of an intruder. When the male coyote did not want to be seen, he expertly made use of every bit of cover. Belly-crawling through the greenery, taking advantage of every fold of ground, he would contrive to get himself within charging distance of a squirrel without alarming it or any of its neighbors. Then he would freeze, patiently waiting for his prey to feed away from its hole, watching its every move till it looked away. When everything was right, he burst into a gray streak of action. He rarely missed adding a luckless victim to the string of groceries carried to the den.

Once I saw him frustrated in an unexpected way. He came out of a grove of aspens to thread slowly through a bunch of cows grazing and loafing with their calves in a meadow. Apparently they were accustomed to seeing him, for they paid scant attention, and he was very diplomatic about not irritating the mothers by getting too close to their calves. Using them for a screen, he stalked a fat squirrel sitting bolt upright on the dirt mound in front of its den. Closer and closer he crept until he finally slid into position behind a camouflaging tuft of grass, and there he froze with feet all drawn up, waiting for the squirrel to begin to feed. The squirrel finally moved, and so keen was the coyote's concentration that he did not notice a curious calf tiptoeing up behind him. Just as he was about to launch himself in a charge, the calf sniffed the end of his outstretched tail. He was so startled that he leaped straight up onto his feet. But the squirrel had not seen him, so he turned his attention back to it, flattening out and getting ready for a rush. Again, when he was just ready to explode into action, the mischievous calf sneaked up to sniff his tail. This time the coyote did not look back, but streaked toward his intended victim. But his timing was now off, and the squirrel dodged him and escaped into its hole. As he stood looking back toward the calf, that coyote's expression was one of pure disgust and frustration. Then he trotted away, doubtless looking for a place where the interference was less nerve-racking.

Again, when I was watching the pups outside their den from a screen of brush on top of a knoll a hundred yards away, the female came up behind me and got my wind. She barked in alarm and instantly every pup shot out of sight into the den. When I came back a couple of days later, the whole family had moved to a new location. In spite of careful searching I could not find them.

But I still saw the parents hunting on occasion. Then, one day as I was sitting on the veranda looking down over a neighbor's fresh-cut hayfield where the swaths were curing in the sun about ready for baling, out of a stringer of cottonwoods along a fence line came my acquaintances, the coyotes—both parents and three pups. One of the pups had disappeared since I had last seen them. The remaining

22

three were almost full grown now, and they were slipping through the scenery, evidently taking one of their first hunting lessons, for when they came to the swaths, the parents began to hunt mice. Trotting along a swath, the male stopped and lifted a paw with his nose pointed into the loose hay, every line of him a study of concentration. Then he pounced and shortly came up with a fat vole dangling from his jaws, which he speedily ate. The mother caught another, and she also promptly ate it, with no more than a glance at the nearest pup.

It was a lesson by example, and before long the pups were all imitating their parents. Their enthusiasm was much greater than their skill, for several opportunities were missed, but two of the pups managed to catch a mouse before they all moved out of my sight into a hollow.

In a few weeks they would all be wearing heavy winter coats, hunting regularly, living off the land by their wits, sharing a valley and mountain with me, and lifting their voices to the stars on clear frosty evenings. They are a part of the wilds, and so am I—all partaking of a host of riches.

WAPITI LAND

It was midmorning on a fine July day when a friend and I rode up onto a ridgetop overlooking a timberline basin in the heart of the Rockies. In front and below us the creek draining the place was shrouded in green timber and bent in a curve under a solid unbroken wall of limestone two thousand feet high and a mile long, a part of the Continental Divide stretching away, peak after peak, until it faded into the haze of the distance.

Although not an animal was in sight, we knew there were elk here. The trails were full of fresh tracks, and every meadow we had ridden across had flattened-out places among the grass and flowers where the animals had bedded down between feeds. We had seen no signs of other humans for days, which meant the elk were undisturbed in the kind of country they always choose for summer range—high, wild, and quiet with an abundance of good grass and cold water.

We were hunting, but not with steaks in mind, for my friend cradled a motion-picture camera in the crook of his arm and was tasting his first excitement of filming animals in some of the finest big-game country left in the world. We rested our horses after the long stiff climb, sitting our saddles in a screening clump of timberline pines as we played our glasses across the reaches of the basin. The trees were all bent and twisted from a lifetime of fighting wind and heavy snows. Down slope, three hundred yards away, the water of a little lake shone through the trees. Beside it a saddle-brown spot showing on the edge of a little green meadow suddenly disappeared from the field of my binoculars. I knew it was an elk.

I slipped out of the saddle and motioned for Frank to follow, and we left our horses ground-hitched as we eased down toward the lake.

This is the ultimate kind of hunting—stalking for the sake of stalking, pitting one's wits against the razor-sharp senses of animals keeping themselves alive by their noses, ears, eyes, and intelligence. When a man can slip in close to a herd in their choice of terrain without alarming them, he knows he is a hunter second to none, and he is aware of it without having to shed a drop of their blood. He can

be as greedy as his skill allows without a qualm of conscience or any fear of bag limits or regulations, limited only by the quality of his patience and leg muscles. It is a sport loaded with excitement; anything can happen and sometimes does, usually without a moment's warning.

This was to be one of those times, for when we reached a spot in the timber perhaps a hundred yards from the lake, we found the place alive with elk. There were so many that we were instantly pinned down. To move another foot would certainly give us away. It was tantalizing because our position was impossible for photography. To make matters worse, two cows sprang out of cover into the lake. They leaped and spun in play, throwing showers of spray high over their backs. Between the intervening trees we could see just enough to know what we were missing. We were tempted to try to move to a better position, but we knew that if we did so the reason for moving would probably be gone. Finally we attempted it anyway and had taken barely three steps when a bull stepped out of a thicket thirty yards away. He looked squarely at us, every line of him triggered for instant flight. We froze, but it was too late. The next instant the timber began to crack as the herd went stampeding away, and we were suddenly aware of being very much alone.

"Now you see it, now you don't," I murmured ruefully. "I knew better but couldn't stay put."

"I was wishing I could reach out and pull some trees out of the way," Frank said, and then added wistfully, "Do you think we'll ever see anything like that again?"

One can never tell what is around the next bend of the trail or hidden by the next ridge. Only a couple of times through the years had I seen elk playing in water, but that did not say that we would not see the same thing again in the next few days. It is the luck of the game that makes it doubly fascinating. About all I could promise was that we would see more elk—plenty of them—before this trip was over.

Three days later we were riding through a stretch of old glacial moraine under the face of a high peak farther along the range, in a place where emerald-green meadows spangled with alpine flowers lay trapped among the folds of the mountain. My horse put his head over a rise of ground, just where a game trail threaded its way between two piles of lichen-painted boulders, and suddenly stopped with his ears up and pointing at something in a hollow beyond. There, lying dead to the world in the warm sun, were a dozen cow elk with their calves. I eased my horse back and stepped down. A moment later Frank and I sneaked up behind a rock with the cameras ready. He ran his camera dry, reloaded, and was all set to shoot again when I stopped him, for this was enough of a record of what amounted to inanimate elk pie. Taking off my hat, I stood up, waved it, and whistled. One old cow sleepily raised her head. We could see her eyes widening in surprise as she came to her feet. A moment later they were all on the run out of there and over a hogback ridge beyond. Frank was about to go after them, but I stopped him.

"Let's lunch here," I suggested. "Give them a chance to settle down, and then I think I might show you something new. I have a hunch there's a big bunch somewhere close, and maybe these have joined them."

It was one of those times when a guide can draw on his previous experience to call a shot before it is made. As it turned out, we were not disappointed.

An hour later we rode over a low ridge at the foot of a pass and reined in to overlook a great sweep of alpine meadow. The whole place was swarming with elk—bulls, cows, and calves—more than a hundred head of them. Against the striking mountain backdrop, it was a picture to remember, and we took full advantage of it.

First we shot them while they were still unaware of our presence, and then we got their reaction as they realized we were in the vicinity. The elk were wary, and I expected them to run over the pass, but instead they suddenly milled in a great running circle. It was a magnificent sight, like something from the days when the only human spectators would have been wearing paint and feathers. To add to the quality of the beauty and action, a small bunch of bighorn rams came flying down off the mountain to mingle with the elk, as though the excitement were more than they could stand without participating in it.

We shot film and more film and then some more until we were finally left standing looking at an empty place in the scenery, wondering if we had been dreaming.

So it goes when you fraternize with elk, the second largest and by far the most dramatic of the deer of the world.

When is an elk not an elk? This question can perhaps best be answered by saying when it is a wapiti, for although the Pilgrim fathers mistakenly called them elk after the European moose, their original Indian name is the correct one. But elk we still call them, and elk they will probably remain to most of us.

To those who have always known elk and watched them through the seasons from calving time through the bitter cold days of winter, they will always be symbolic of the high country of western North America. They are big, handsome animals, classically proportioned, proud, intelligent, and very enterprising when it comes to finding the best feed available. To those who have never seen deer bigger than whitetails, elk are indelibly impressive—especially in the fall, when the bulls, their antlers polished, fill the valleys with their bugling as they contest for the females.

Although I have seen thousands of them in about every condition possible, the sound of a big herdmaster bull bugling his challenge during the mating moon of September sends a thrill along my spine. My memory is still sharp with the dramatic picture of a scene witnessed one evening in early September years ago in a wild mountain valley.

It had been raining hard all day, a straight-down heavy rain that soaked everything and kept us in

our tents, close to the warmth of the sheet-iron stoves. When it quit an hour before sunset, I went alone for a walk up the river. A mile above camp the trail took me to the edge of a meadow flanking a gravel bar. On either side, along the lower slopes of the mountains, big timber bordered the meadow. It had turned colder, and the clouds were breaking into lazy stringers of mist. High overhead, through a rift in the haze, the spire of a peak showed, all covered with new snow shining in the sun. It was a classic wilderness scene, and very quiet except for the gentle murmur of the river.

Then came a sound as wild as the picture before me—the challenging call of a bull elk echoing like organ notes off the slopes of a deep, twisted ravine running steeply down into the valley from the north, through parks of spruce and larch. A flicker of movement showed through the big timber, in a grove of Western larches just turned to autumn gold, and my binoculars revealed a herd of twenty-odd cows and calves following a game trail down off the mountain. As I watched, another bull sounded off to one side. He was immediately answered by the first, a magnificent bull which came trotting into view, trailing the cows. His antlers were widespread, massive, and a rich mahogany brown. Six long points showed on each curved beam, their tips gleaming like burnished ivory. The great bull was in prime condition, his light buckskin coat darkening to deep brown and almost black on his neck ruff, legs, and belly. Here was a typical herdmaster trailing with his cows, guarding his harem from the attentions of the other bulls now bugling steadily all over the slope.

As they dropped down the last steep pitch toward the valley floor, the cows all broke into a run, but the bull walked proudly out on top of an outcrop of rock, laid his antlers back along his flanks, and bugled a reply to his rivals. First a deep note lifted through three higher ones into a long pealing whistle, then dropped to an explosive grunt that sent steam shooting from his open mouth. Finally he turned and trotted away out of sight after the cows.

The cow herd showed up on the edge of the meadow directly in front of me. They were obviously warming up after the cold, soaking rain. The big old dry lead cow wheeled out onto the flat, leading the bunch in a half circle at a gallop; then they all stopped, facing back toward the slope. Two cows reared, their noses pointed toward the sky, and almost touched briskets as they playfully pawed each other with their front hooves. Several calves bucked and gamboled around the herd. The big herd bull came trotting out of the timber with nose extended and antlers laid back. He went straight to a young smoky-buckskin-colored cow, but she sidestepped him with a playful flourish of her rear. Each animal had a plume of steam standing over its nose at each breath.

The herd bull stopped, lowered his head with nose thrust out, and gave a warbling series of low-pitched musical notes that seemed more like the call of a bird than the voice of a big animal—a liquid sound like that of water poured from a big glass demijohn. He wound up this rendition with another great grunt, sending a shaft of steam shooting at least ten feet out from his mouth.

Four lesser bulls came out of the timber and circled the herd. The air was full of their bugling. The herdmaster charged one that dared approach the young cow. The usurper fled, but as he turned, the point of an antler cut from his rump a ribbon of hair that floated away to the side. The herdmaster circled the flat, driving away his rivals one by one. All had apparently tested him before, for none was inclined to fight. When the last one was driven back into the timber, he came striding arrogantly back into the herd with head low and antlers swinging in time to his strides.

He walked directly up to the young cow, now suddenly passive, reared and covered her, while the rest of the herd grazed all around. It was an utterly beautiful and magnificent picture of procreation fitting to the wilds. Overhead the peak was lighted in deep rose over a silver collar of mist, while the river sang its soft song to the big trees beside it.

WILDERNESS ADVENTURE

Henry David Thoreau said: "We need the tonic of wildness—to wade sometimes in marshes where the bittern and the meadow-hen lurk, and hear the booming of the snipe; to smell the whispering sedge where only some wilder and more solitary fowl builds her nest, and the mink crawls with its belly close to the ground. At the same time that we are earnest to explore and learn all things, we require that all things be mysterious and unexplorable, that land and sea be infinitely wild, unsurveyed and unfathomed by us because unfathomable. We can never have enough of Nature. We must be refreshed by the sight of inexhaustible vigor, vast and Titanic features, the seacoast with its wrecks, the wilderness with its living and its decaying trees, the thundercloud, and the rain which lasts three weeks and produces freshets. We need to witness our own limits transgressed, and some life pasturing freely where we never wander."

Thoreau spoke of his beloved New England country more than a century ago, but the principle and spirit of his words apply just as well to the mountain regions of the West today, for here, too, "the mink crawls with its belly close to the ground," and it is good for us to see our own limits transgressed. In mountains there is something grand that puts man in his true perspective, giving him a look at himself as just another warm blooded thing breathing and crawling across the face of an immensity, sharing an ecosystem with bears, elk, wild sheep, and other wild things, including the little white-footed mouse and the mosquito.

If we are to call ourselves civilized, then we cannot look at a mountain in avarice and greed alone, reducing it to mere long tons and board feet, savoring it for what it might yield in fossil fuels, minerals, and lumber. We must see its beauty and stand in awe of its inexhaustible capacity to act as a storehouse for water to nurture the ever-demanding requirements of all living things; we must be aware of its function as a vault for the safekeeping of the riches it contains, a place where unfettered spirits can wander wild and free. In looking at the craggy features splitting the very clouds that blow across the sky, we need this reminder that we must weigh the destructive power of our technology and balance it with nature if we are to assure our vital environmental needs. If we do these things, thinking with an open

31

mind and heart, we will know that wilderness is truly a part of all life, where some things are measureless, mysterious and blue, deep to the ends of the universe. Otherwise we blight our bodies and our souls in a morass of destruction and filth with no hope for the future.

As one who has wandered in wild places all the years of his life, I have known firsthand the beauty, mystery, serenity, and utter savagery of nature throughout the vigorous seasons of this Northern Hemisphere.

I have ridden my horse scouting ahead of a packtrain along the narrow trails of the Salmon River country in Idaho at greening-up time in spring—trails threading their way so precariously across cliffs above the boiling river that if two horsemen met at a blind corner, one would inevitably fall, for there would be no way to turn around. Indeed, there were places so narrow that a man could not even dismount in safety. If one chose to ride in those places, he stayed in the saddle till the trail widened again.

I remember one rider who tried to change his mind. He fell into the river and disappeared. The following spring I was fishing a deep run miles downstream and saw something flapping in the swift current six feet down or more. Waiting for a slick in the boiling current, I looked again and distinctly saw a stirrup waving on its leather—the rest of the saddle and perhaps the remains of the horse were buried out of sight in the gravel—the man long gone, his shell claimed by that merciless river.

The experience was stark, but the place was utterly magnificent. Snow-draped peaks gleamed high overhead, and the lower slopes were bright with new grass and the pastel shades of new leaves and bloom on scrub oak and sage. Mule deer grazed and browsed along the river in hundreds. Bighorn sheep threaded narrow trails across the lower rock battlements and the talus slides. Mountain lions prowled the thickets and broken rock, preying on the deer and sheep. We saw their tracks, heard them call, and counted their kills, but never laid eyes on one of the big cats, so secretive were they. At night flocks of bats emerged from cracks and caves on the rock faces to swoop and dart far and wide for insects, and great horned owls hooted among scattered groves of timber.

We slept on the ground with the muted roaring of the river always in our ears as it flowed swiftly down its water-carved way into a canyon so steep and wild that only the birds flew down its narrow cleft and mountain goats walked airy trails like bad dreams. No man could climb through that canyon, its walls overhanging in places, except on the river ice in winter, and then only at great risk. Its depths were inviolate.

Truly, this is wild country.

I have sat on top of a hump in a vast moraine in the St. Elias Mountains of the Yukon Territory, away back beyond the last faint sign of man, and watched the icefalls boom and cascade off hanging glaciers that cling to the almost sheer face of a peak cleaving the blue sky like a great white tooth. The cannonading of falling ice was punctuated by spurts of snow dust as great chunks hit unyielding rock

and shattered. In spite of the impact, many pieces weighing tons reached the foot of the mountain intact. It was a salutary thing to see a mountain spitting out great masses of ice that it had grown tired of holding over the millennia it took to form, getting rid of a weight that had faulted itself past the angle of repose—masses exceeding the bulk of the small hills nearby.

A golden-crown sparrow perched on a sharp rock looked at me, paying not the slightest attention to the rumble and roar of the icefall. While his mate warmed eggs in a nest close by, he chirped with worry at my presence, a tiny, vibrantly alive thing in the midst of exceeding vastness.

I have rested on a dry cushion of tundra, comfortable in the warm sun, watching a trio of timber wolves trying a run at a bunch of caribou to see if there was one with some infirmity sufficient to warrant a successful catch. The wolves know that they cannot catch a caribou on such good footing simply for want of enough speed, so they will run a bunch long enough to spot a weakling. Three times they worked various small herds and every time gave up the chase, sitting with tongues lolling out of their mouths, frustrated. No easy lunch that day. Perhaps they settled for a meal of snowshoe hare or voles. Nature smiled benignly on the caribou after putting them through this test to find weaklings that needed to be weeded out. Thus vigorous strains are maintained within the wild, a play of genetics practiced ages before man ever invented the word.

Cruel, you say? So is hunger gnawing at a wolf's belly.

My sons and I stood one night on the edge of the great valley where the mighty Peace River winds; we felt very small, like little boys standing behind darkened footlights in some vast, empty theater, while a celestial stagehand amused himself with colored lights and curtains overhead. The lights, green and red and opal, undulated in silken folds, sometimes lifting to the uttermost limits of the stars, then lowering so close that we were tempted to reach up and try to touch them. We stood in awe under the northern lights, for:

> "—the skies of night were alive with light,
> with a throbbing thrilling flame;
> Amber and rose and violet, opal and gold it came.
> It swept the sky like a giant scythe,
> it quivered back to a wedge;
> Argently bright, it cleft the night
> with a wavy golden edge.
> Pennants of silver waved and streamed,
> lazy banners unfurled;
> Sudden splendors of sabres gleamed,
> lightning javelins were hurled.

There in awe we crouched and saw with
our wild, uplifted eyes
Charge and retire the hosts of fire in the
battlefield of the skies."

So said Robert W. Service, and he said it well.

The display faded to white and pale pink to march away back toward the curve of the polar rim and lose itself. Silent, we went to bed knowing we lay in the midst of wildness and were part of it, even if we did not fully understand.

THE SHEEP WITH THE
GOLDEN HORNS

Of all the wild sheep in the mountains, from the province of Sonora in Mexico to the northern ranges sloping off into the Beaufort Sea, there are none so attractive as the snow-white Dalls of western Yukon Territory. Here the rams grow long, flaring golden-colored horns that sometimes achieve a length of forty inches or more along the outside curls.

Well I remember a brilliant September day north of Kluane Lake, in the vicinity of a fork of Gladstone Creek, when a friend and I climbed over the great dome of a limestone mountain to a lookout point that was little more than a pile of half-broken boulders standing a few feet above the general symmetrical contour, and looked out across a great valley, then down a little onto the top of the opposite ridge. Our position of dominance gave us an advantage, for we could see into the sheep basins sloping off the near side of this ridge, and even into parts of some on the other side.

The air had a crystalline quality found in the north as in few other places in the world, the sun warm but with an autumn nip lingering from the frost of the previous night. Over it all lay that profound silence known only in the far North, a hush so complete that one hesitated to speak or even whisper.

We stood still for a few moments, specks in an immensity, full of awe as though in the presence of the Great Spirit under the cathedral arch of sky, and dared not move to break the spell. This was the sun's kiss of good-bye to summer here. Approaching winter was celebrating summer's swift decline by playing its fingers of first frost seductively over the dwarf willow and birch of the tundra ground carpet, painting it in hues of utter abandon, from scarlet to bright yellow. The mellow hush was the prelude to the iron chill of the howling blasts to come, when driving winds and snow would turn this paradise into a white hell, asking no quarter of any living thing and giving none.

We shrugged off our packs and lay down behind them. We took turns peering through a high-powered spotting scope at various points of interest revealed among the mountains—the magic of pre-

cision lenses at first turning what looked like live things into lumps of stone and then suddenly giving them life again. In the great open sweep of a basin running down off a dome just over the sharp-edged ridge, there was a bachelors' club of rams loafing away the afternoon in beds pawed deep in loose talus. I counted seventeen without undue excitement, for though the bunch was a large one for what were mostly mature animals, sheep were plentiful here and already that day we had walked past scores. The play of the sun was causing a mirage to appear along the rim of the ridge, the rising heat waves erasing detail, so that although horns were visible there was no way of telling how big they were at a range of a mile. We played the glass elsewhere near and far, reaping the pure pleasure of looking after our long climb. We were profligate with time, for its passage meant nothing here, and we were vastly comfortable, lying stretched out on a Persian carpet of tundra that covered the ground between the rocks. So time passed and the sun lowered a bit, changing its angle and losing power enough to erase the bouncing waves of mirage between us and the sheep.

Curious, I swung the glass onto them again and caught my breath, for there was a ram lying outlined against a patch of pearl-gray rock with horns like few I have ever seen. They swept back from their bases and flared, dipping back toward his head a little on their downward curve, then turned up and out again with points well past the full curl. Eight rams of the seventeen wore horns of full curl or more, but this one surpassed all the others, making them look mediocre.

It was too late and distant to get closer that day, so we went back to camp. Early the next morning we were heading back, hoping for pictures of the big ram at close range. At the last moment, against our better judgment, we consented to take a couple of cheechakos with us—strangers to the mountains of the North—enthusiastic, pleasant fellows, but so green, as my partner put it, that they were in danger of being eaten by caribou. It was our intention to climb the mountain at the head of the basin and from there try to relocate the bachelors' club and make a stalk. It was a long way to the top of the mountain and nearly noon when we climbed up over a stretch of broken boulders to the summit.

There was a skiff of new snow from a passing squall the night before lying about an inch deep over everything. The first thing we saw among the broken boulders strewn over the little saucer-shaped plateau was paint-fresh ram tracks. We knew the rams must be right in front of us somewhere, hidden among the rocks, so we deployed to a rim of rock that gave us a slight advantage of elevation as we waited for the rams to show themselves. But impatience is the hallmark of the inexperienced in this game, and before long one of our guests got itchy feet and went to another boulder close by. On the way he upset a loose rock with a rattle of sound, and the next instant, about eighty yards away, ten rams leaped into view, springing out of the ground as if by magic. There they stood frozen, so closely bunched that all ten could almost have been covered with a fair-sized blanket, and then they were gone in one bound over the rim and out of sight. My partner and the other two leaped after them, but I did

not move, partly because the years have taught me the futility of wasting energy in trying to catch up to spooked wild sheep and partly because some of the bunch was missing.

Playing the binoculars over the country around us, I almost immediately spotted a string of seven rams single-filing down a trough along a ridge three-quarters of a mile back toward the north. They had been bedded there and had spotted us as we climbed the last pitch to the mountaintop, and now they were on their way, sure of themselves and unhurried. A look through the spotting scope revealed those awesome weapons on the head of the leader, a full forty-six inches on each horn, I estimated, the biggest I had ever seen except one. In spite of much looking in the days that followed, we never saw that bunch again.

One spring years before, I had helped organize the first Canadian expedition to catch Dall sheep alive among the mountains south of Kluane Lake in this same general region. We were after lambs, but these had not begun to show up on the lambing grounds when we arrived near the first of May, so I occupied my time scouting through the mountains, exploring and gathering motion-picture footage of sheep and other things. The sheep were handsome in long winter coats that glistened snow white against the new green of spring.

There were hundreds of sheep on the lower levels. The rams were particularly fond of anemone blooms. The plants grew profusely on the benches just above treeline, so my filming was easier than any that would ordinarily be encountered.

Climbing higher than usual along the rim of a deep, twisted canyon, I came out one morning on a shoulder overlooking a vast expanse of steep tundra-covered slope beyond and above. It was hot and I was tired and thirsty when I sat down on top of a rock outcrop to use my binoculars. Immediately I spotted a lone ram lying on the tip of a granite buttress far above, a tremendous ram wearing the largest horns ever seen in all my rambling through the North.

He was all alone and very old. In the evening of their years some of these big old males take up a solitary life, due perhaps to an injury to their legs or a loss of teeth that saps their energy and slows them up. Hard put to keep up with younger animals, they make use of wits and guile sharpened by years of experience to stave off the merciless inroads of time. This one had chosen his bed ground well— it commanded the whole face of the mountain. There he lay with those magnificent golden horns outlined against the brilliant blue of the sky—a most enticing picture.

For hours I patiently worked to approach him, my thirst and weary legs forgotten. I got close enough to see the form and detail of those perfectly curved, unblemished horns through my powerful binoculars, but my longest telephoto lens was still out of its best range. He was very shy and finally left me there alone with a pair of ravens and a memory as sharp and clear as the outline of the mountains against the summer sky.

THERE MY STICK FLOATS

One of the West's wild rivers, a magnificent stream full of mystery and beauty, strong in its current, placid in its pools, and still reasonably pure in its waters, winds down between folded hills, blue and silver in the sun, alternating fast white water and slick runs with quiet holes. Beyond the hills the Rockies rise, tall and craggy, their expressions strong in profile, enduring through the millennia since the earth's crust split to heave them slowly up toward the sky.

For two hours I had been fishing, standing thigh-deep in the river and enjoying the powerful tugging of its current against my legs—soothing medicine to wipe away the tension. There are few things as satisfying as plying a finely balanced fly rod and line in presenting a hand-dressed fly to feeding trout. While a full creel has no part in the witchery, mine hung comfortably heavy on my shoulder—sufficient promise of a delicious breakfast when the sun rose again.

The fishing was only part of the river's wealth. There were signs of mink and beaver along the edges of sandbars. Elk, moose, and deer tracks showed here and there, and in one place the big paw marks of a black bear were printed deep in the mud beside a spring.

Earlier in the evening, while the sun was still up and the world still warm after a long hot day, I had come down a steep bank along a little trail. It led me through a pocket close by the river filled with berry brush higher than my head. As I made my way into it through a patch of tall fireweed, the leaves rustled noisily in the breeze, muffling my footsteps. There was a sudden explosive snort and a great crash as a huge whitetail buck with antlers like a rocking chair leaped from his bed into flight, so close I could have touched him with the tip of my rod. My thoughts had been somewhere else, and the suddenness of it made my pulse jump a bit, but doubtless less than his at having me almost walk on his tail.

Later, as the evening cooled and I was standing knee-deep in water at the tail of a pool, I watched a doe browsing delicately among some saskatoon bushes, alternating choosy nibbles of leaves and twigs with enthusiastic mouthfuls of the luscious ripe fruit.

The sun dipped down onto the far rim of the mountains to the northwest, throwing long shadows of trees and promontories along the opposite bank. I shot my line upstream to drop a tiny fly where an eddy curled by some big rocks. There it danced, light-footed as a mayfly, when suddenly the *kerplop* and splash of a diving beaver sounded behind me. Swinging my head to look, I let the fly drift unattended for a moment and missed the strike of a good trout. The beaver surfaced to swim toward me, full of curiosity, his whiskers working on each side of his face like an animated mustache as he tried to get my scent. My chuckle triggered another great tail-smacking dive that threw water in all directions.

My attention to my fishing had been broken again, but such is a love affair with a beautiful river, and now I stood contemplating it, full of wonder at all the life it had known and felt over the long reaches of time far beyond the moons before I was born. It was to places like this that the first white men came, some of the old mountain men—free trappers adventuring in search of beaver. They may have stood here braving the dangers of wrathful Blackfeet just for the privilege of looking at new territory and taking some skins. They had seen the ancestors of my beaver, the deer, and other game, their spirits lifting as mine did at the sight of a flaming sunset over the mountains.

For a few mystic moments the shadows of Old Bill Williams, Jedediah Smith, John Fitzgerald, and others like them stood close beside me, contemplating the river, leaning on their long rifles with the breeze stirring the fringes of buckskins redolent with the smoke of a thousand campfires. A peeled beaver stick floated by in the lazy current, bringing to mind something just beyond the edge of recall— something heard or read long ago.

Then a great horned owl suddenly broke the silence from some cottonwoods across the river. "Who? Who? Who?" it called as though questioning my thoughts.

Then I remembered. It was Old Bill Williams, of course! When something pleased him or he liked a place, he would say, "Thar my stick floats!" And come to think of it, there my stick floats too.

THE SPEEDSTER AND
THE SLOWPOKE

Nature is fond of developing specialists of one kind or another in the animal world, species specially adapted to their surroundings in ways that make them unique. Two such animals found on the plains and in the high country of the West are almost complete opposites in choice of range and in certain physical attributes, yet they are relatives. They are the pronghorn antelope and the mountain goat.

Incongruously enough, the pronghorn is more of a goat than an antelope, and the mountain goat is more closely related to the antelope. If one were to draw a geographic comparison, with Africa representing the antelope family and North America the family of goats, the mountain goat would be located somewhere in the vicinity of the Canary Islands. The mountain goat is a link between the two species but is much closer to the antelope family.

The pronghorn antelope of North America's plains and plateaus is one of nature's most refined achievements among the cloven-hoofed animals in its adaptation to life on the open prairies. Its frame and muscular development are superbly constructed for fleetness of foot, and it depends largely on speed to protect itself from enemies it has been clocked at sixty miles per hour. It is the only cloven-hoofed animal of the entire world which has no dewclaws—the secondary toes, or, more correctly, heels, that project from the back of the hoofs of all other ruminants. Perhaps these were lost over many thousands of years of evolutionary process by being repeatedly torn off when the antelopes turned at high speed on rough ground. The pronghorn is the only animal wearing true horns which sheds them annually; each year the bucks shed the outer shells of their weapons and grow new ones.

The color of the pronghorn is a rich tan and white with pelage of the same nature as the deer: the hair is tubular and offers very effective insulation against both heat and cold. The rump patch of snow-white is very pronounced and can be fanned out, in moments of alarm, to form a flashing, danger-signaling heliograph that other pronghorns can see for miles. From the front, or quartering on from the side, a

pronghorn is difficult to see against the natural background of tawny plains grass, but when it turns to go, its rump patch flashes like a mirror.

By contrast, its relative the mountain goat lives in the standing-on-end country of the mountains, walking with utter unconcern along airy ledges. With characteristic deliberation it can climb places where it would seem a fly would have trouble sticking to the rock. Its feet are specially designed, with soft rubbery pads on the soles cupped in rims of hard horn. These stick well to almost any surface, enabling the animal to defy what would appear to be the inevitable law of gravity. The goats' cannon bones are very short, allowing them to reach up, place a foot in a tiny crevice, and then lift their weight. Phlegmatic by nature, they outclimb enemies more than they run from them. Understandably enough, nobody has clocked their speed, but it is doubtful that a mountain goat can achieve more than twenty miles an hour on the most ideal footing.

The whole frame and muscle structure of the mountain goat is put together for climbing and living on high rock terrain. Mountain goats are narrow and slab-sided, with horns that do not project to the side, and thus they are able to traverse narrow ledges without danger of being tipped off into space by their own bulk. Their coats are long and creamy white, with fairly coarse guard hair covering an undercoat of fine wool. When fully haired-out for winter, they present a rugged picture that is in sharp contrast to bare rock or that blends with the snow. A billy and nanny are hard to tell apart, for both have baggy pantaloons hanging to the knees, thick coats, pronounced neck ruffs, and long flowing beards. Both sexes wear short, curved, and very sharp black horns that they keep honed like the points of stilettos, sharpening them on the rocks. The horns of the females are often longer than those of males of similar age but are much slimmer at the base.

When the white man came to the West about one hundred and fifty years ago, he encountered pronghorns and mountain goats for the first time. He had little interest in the goats, for he was traveling by boat or on horseback and had no ambition to spend the time and energy pursuing these climbers of the crags. The pronghorns were the "lunch meat" of the frontiersman; they were everywhere on the Great Plains, could be killed with relative ease, and were easy to handle. Even the biggest bucks weigh only about eighty pounds, hog-dressed. Consequently, when the settlers came pouring in, the pronghorns were killed off or further reduced by disruption of their environment. Today only a comparative handful remains.

When wire fences began cutting up the prairies, the antelope were in trouble. At first they were afraid of the wire. The only way they could get through a fence was by crawling under it, something rather difficult to do at high speed. In spite of their nimble feet, they are not jumpers. But with the passing of time, they have adapted to the wire. I recall sitting on a low knoll in the extreme southeast corner of Alberta one November day, watching about forty antelope running across country. A stout barbed-

wire fence was dead ahead of them, marking the boundary between Alberta and Saskatchewan, and when the band came to it at a leisurely forty miles an hour or so, they just flipped on their sides and passed between the strands, scarcely touching them and not losing a stride. Occasionally the bucks tangle their horns during this maneuver and pull off the shells.

Again, in this same region, I had the chance to test their speed while driving a station wagon along a country road. A bunch of about fifty head came pouring across a flat, quartering to me with the obvious intention of crossing in front of the car, as they love to do. I stepped up my speed to fifty miles an hour, about the limit for the condition of the road, and for perhaps half a mile the pronghorns cruised along beside me, running effortlessly. Then they tired of my company and speeded up. When I was going fifty-five miles an hour, they passed in front of me, then tore up a draw with plumes of dust at their heels, and disappeared among some hills. They had to be going more than sixty miles an hour to make such a move. The only other animals of the world which can match their speed is the cheetah of Africa and the black buck of the plains of India.

Their eyes and those of the mountain goat are superbly keen, probably eight times better than those of an average human. While the pronghorn pays strict attention to any intruder who might threaten, the goat may choose to ignore the approach of a man or a predator if it feels safe on some dizzy height. The pronghorn often seems to delight in the slightest excuse to burst into a run for the sheer exuberance of it, while the goat is more inclined to make use of the logistics of its inaccessible terrain for protection. The pronghorn has a wide streak of curiosity built into its nature, a characteristic that can get it into trouble with hunters, who sometimes lure it within range of their rifles by tying a handkerchief on a stick and letting it flutter in the breeze. No such decoy will get more than a look from a mountain goat. Its reaction to danger is usually remarkably phlegmatic. Unless closely pressed, it will rarely break into a gallop.

The pronghorn occupies a land of distant flat horizons where the sun lights up the golden savannas for miles and miles. Sometimes its range penetrates big valleys and plateaus close to the mountains, like those in parts of Montana and Wyoming. Occasionally one sees them setting sail across the great flats where mirages lift and curl, creating an illusion of animals running over water or completely detached from the ground like some sort of speedsters of the sky.

The mountain goat is symbolic of high mountains, where glaciers hang trapped between cliffs, and pinnacles cleave the sky—a land of harsh and varied climate ranging from benign sun to fierce storms. They are born, live out their lives, and die where no other kind of cloven-hoofed game can exist. In summer they sometimes share their range with wild sheep, but often they winter where sheep could not possibly stay alive. For all its austere harshness and violent topography, their world is a magnificence of peaks, an Olympian land fitting a brave and enduring spirit.

AUTUMN GOLD

This is the time of year when all nature seems to celebrate the end of a long, fruitful spring and summer by decorating the face of the land with color, ripening the grass and splashing the leaves of the trees with gold, yellow, red, orange, and rich brown along with about every shade in between thrown in for good measure. Away up at timberline on the faces of the mountains, the September larches stand like golden spires among the evergreens; the larch is the only conifer that sheds its leaves for winter. Down along the valley bottoms where clear creeks wind, banks of majestic cottonwoods stand dressed in gold, their branches hanging over the water. Hidden among the branches of the trees are the abandoned nests of birds, their summer's sheltering of eggs and fledglings done. Some of these will blow away in the wind with the leaves, but others will sturdily defy the elements to gather caps of snow—a reminder of the craft and care taken in their building.

No longer do the timber and brush thickets resound with bird song; the sounds are now muted chirps and restless trills, along with the rush and whisper of flashing wings. My binoculars pick up a flock of several hundred crossbills working through a grove of wind-twisted white pines to find seeds. Not far from them a smaller flock of Bohemian waxwings move through the blood-red leaves of a patch of saskatoon brush, feeding on the dry berries still clinging thickly to the twigs. It is snowing slightly, the first flags of winter signaling the cold to come. With a rush of sound, a flock of nearly two hundred robins sweeps overhead only a few feet above the treetops, heading south. Most of the other thrushes and small songbirds have already gone.

The first flocks of migrating sooty-gray coots are showing up on the bigger lakes. From nesting grounds farther north they are winging their way south on this first winter squall, splitting the wind with their sharp ivory-white beaks and beating their way with short wing strokes as though the effort were almost too much for them. Much more at home on the water, they dive deep for food, using their wings for this, too, although in slower and easier tempo. Without a head wind to aid them, they are hard pushed to take off into the air, but in diving they are in their element, graceful and astonishingly

long-winded. While resting on the surface, they are wont to flock up in thick masses, sometimes numbering in the thousands, seeming to take comfort in togetherness for social warmth and comfort. Although they are unobtrusive, meek, helpless-looking birds, I have seen them bunch suddenly in a thick mass, their beaks upraised, their frantic feet stirring up a flurry of flying water, in their attempt to stand off the attack of a stooping eagle by sheer weight of numbers. Unloved and unadmired by most men, they are rarely pursued as a game bird; they need fear only the winged predators or the occasional mink or coyote which might sneak in close while they rest on shore.

The hawks are also on the move; sparrow hawks, redtails, marsh hawks, prairie falcons, duck hawks, and other predatory birds work their way south toward lands less harsh in winter. They hunt as they go, sometimes perching in tall trees or on ridgetop snags to rest. Sometimes a dozen will be in sight at once with several species represented among them. Their flight is rarely straight, but in a progressive series of interlocking circles as they drift from one thermal to another, riding the wind currents, wild and free, always on the watch for prey, and beautiful to observe. Among them all, only the tough, powerful goshawks will linger here for the winter, stalking their prey with deadly efficiency over deep snow, scouting in low flight through the timber groves.

My roving binoculars pick up black bears on the prowl, stuffing themselves with berries to the point of utter gluttony, their outlines glossy and rolling with accumulated fat. Carefree, jolly animals, they revel in the berry harvest, following their searching noses from one patch to another. A black mother crosses an opening between two patches. Her yearling cubs, still busy stuffing themselves behind her, are slow to follow, but they finally take off at a rolling gallop in pursuit of her fast-vanishing rear. One is so exuberant that it puts its nose down and does a complete somersault, coming up on its feet without missing a stride, as rhythmic and smooth as a trained gymnast.

Toward evening, as the lazy clouds part and lift around the crest of the peaks, I come to a stand in the timber of a wild valley between towering mountain walls and listen to the exciting music of rutting bull elk. Peal upon peal of whistling calls that wind up in deeper tones and gusty grunts echo off the cliffs, making three or four bulls sound like legions as they challenge each other for the favors of the cows. Right in front of me, moving like gray ghosts, silent and unconcerned, are two mule deer bucks. Their antlers are clean and polished like those of the elk, but they are still two months away from their mating season.

Where the creek pours out of a canyon to go meandering across a flat stretch of swamp all red and yellow with the leaves of scrub birch and willow, a bull and cow moose loom huge and jet-black. They look ponderous, but when they move it is pure poetry of motion—a joy of grace and power like none other of the deer tribe of the world. For they are the biggest of all deer and move with ease across bogs where any other of the bigger animals would be in trouble. Their blood is also stirring with the first

flush and heat of the mating moon. This is the cow's first breeding season, and she is on the verge of estrus. The bull eases close to her, shouldering her on the flank, grunting and whining low in his throat, but she shies away, unready to accept him.

The dark closes in, reducing the colors to shades of gray among the brush, and the moose blend into the deeper shadows till my binoculars are hard pressed to pick them out. I turn away toward home, tired, hungry, but soothed and happy after a long, productive day afield. Like true gold, the richness and throbbing life of autumn lie deeper than surface color.

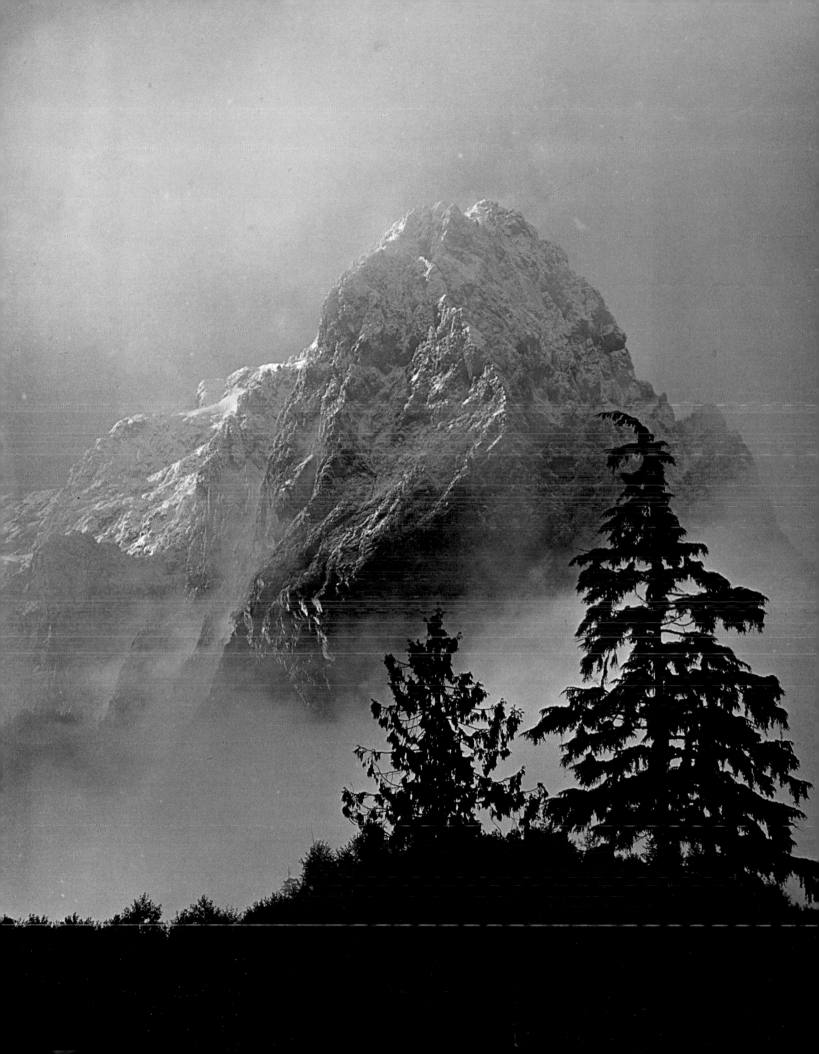

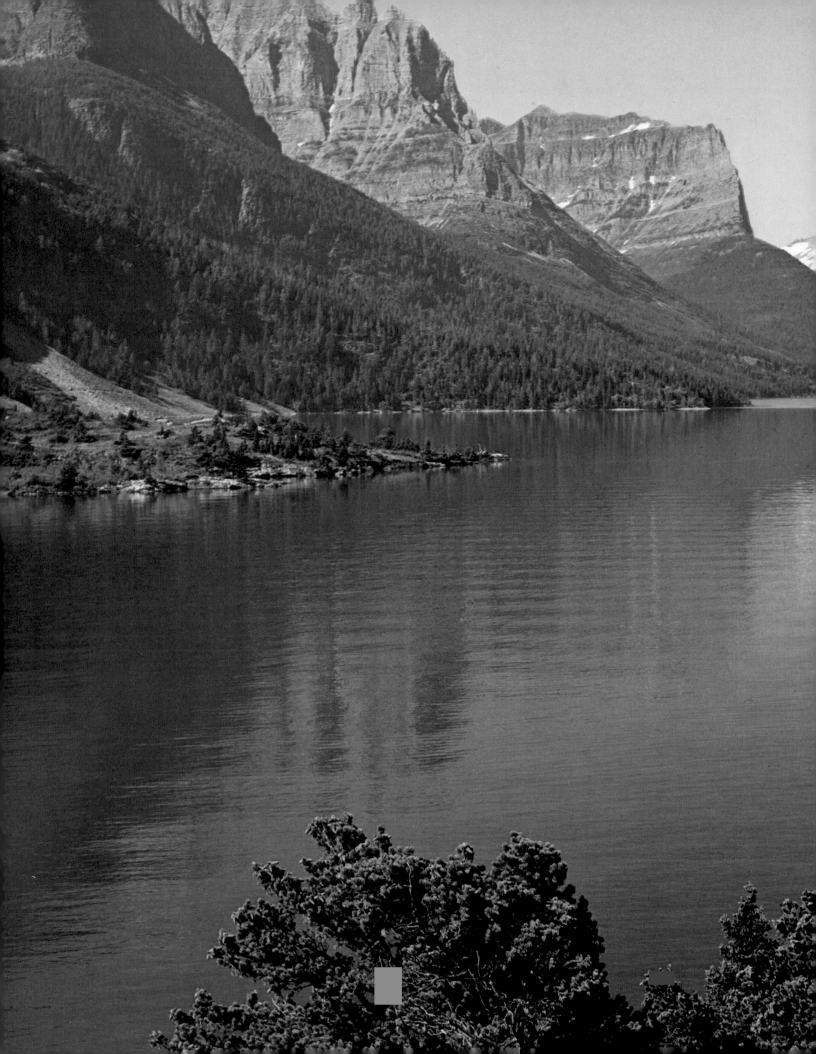

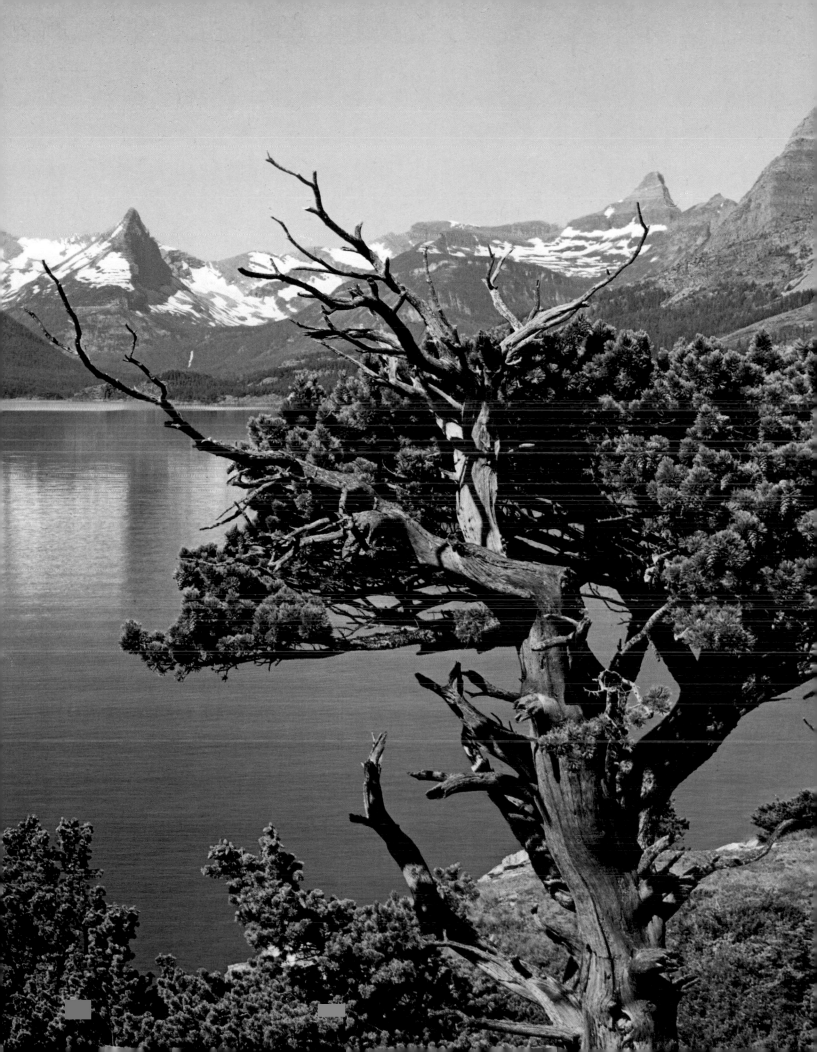

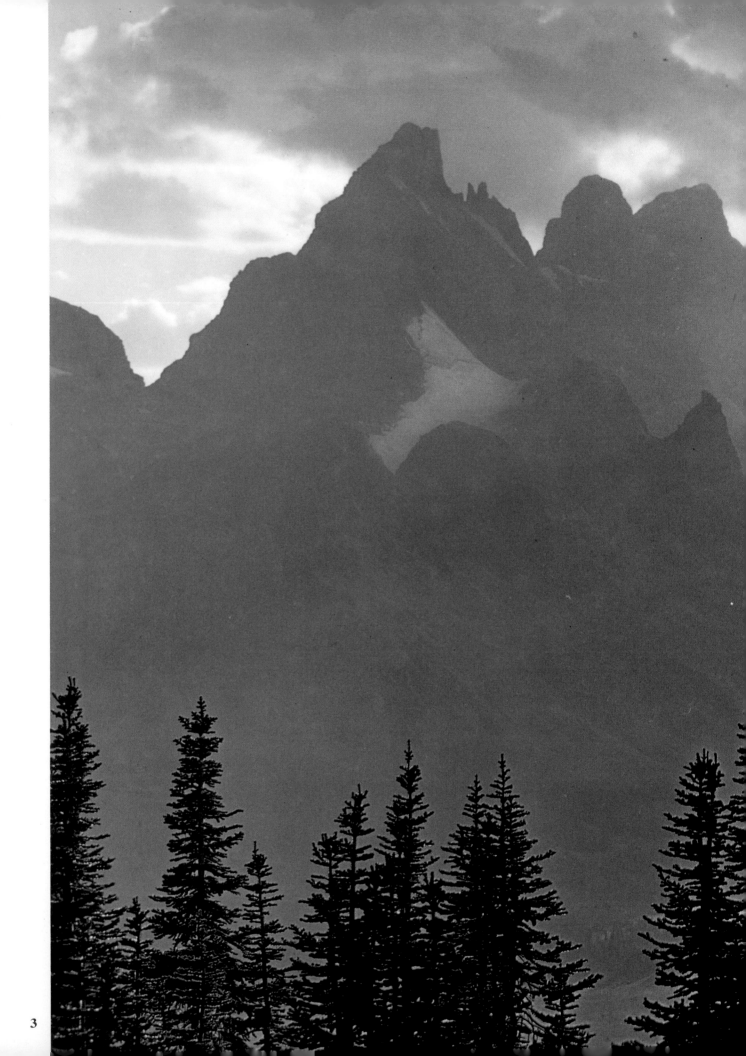

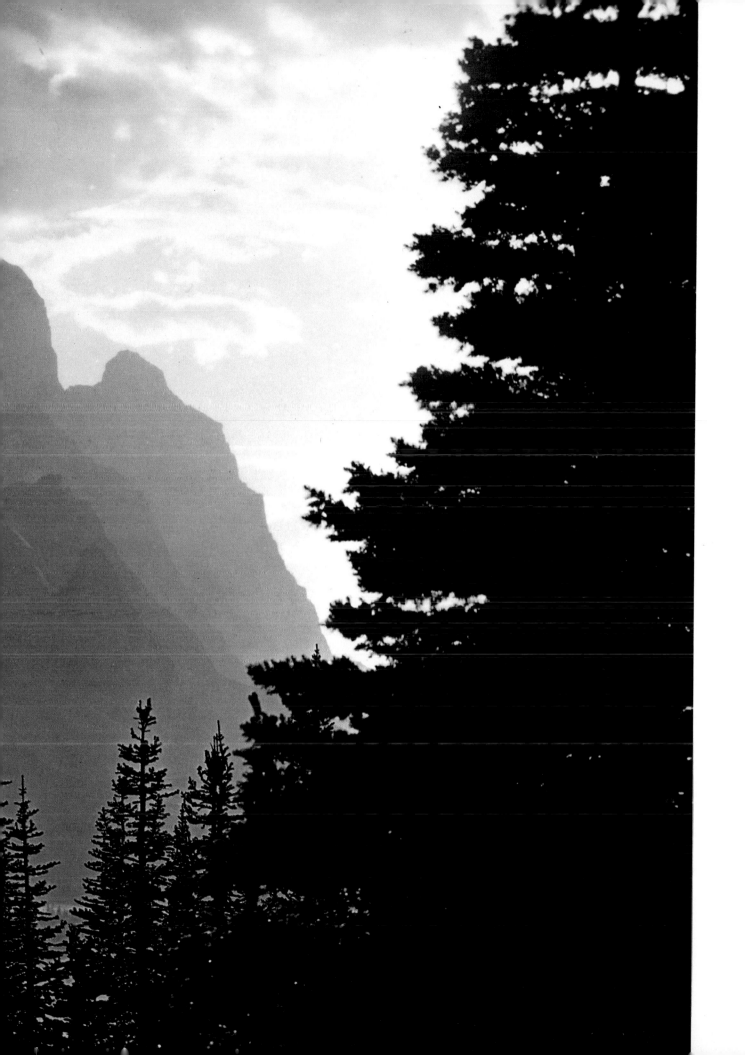

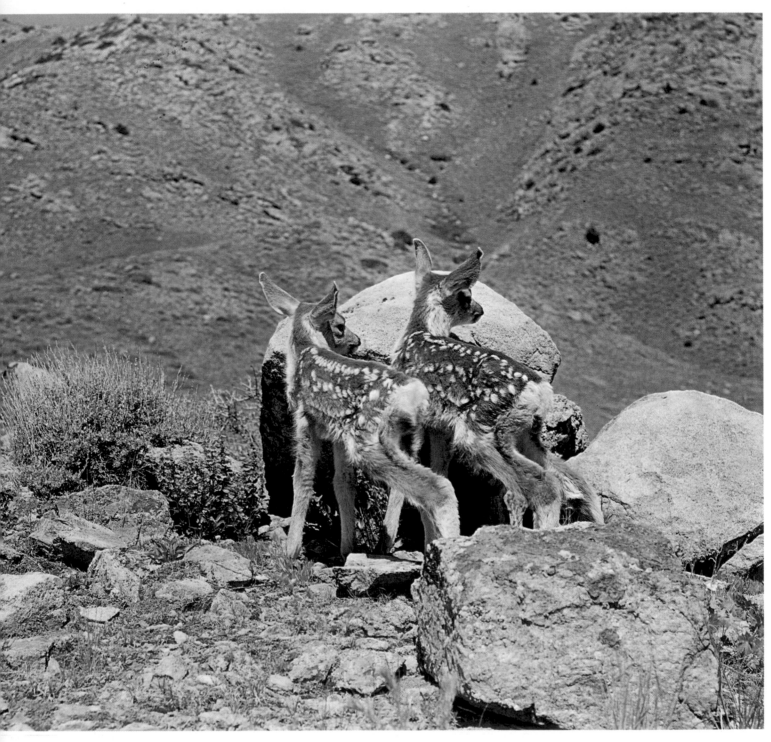

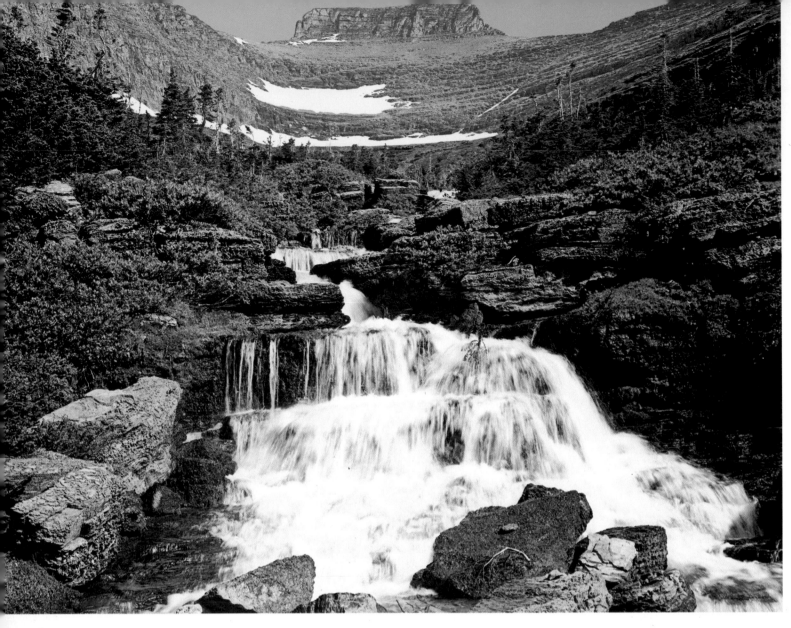

6

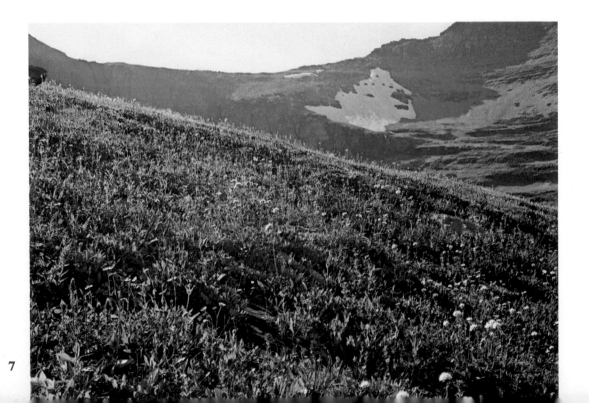

7

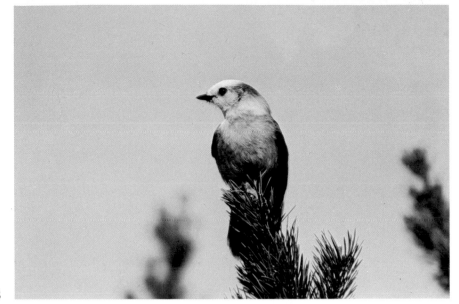

8

9

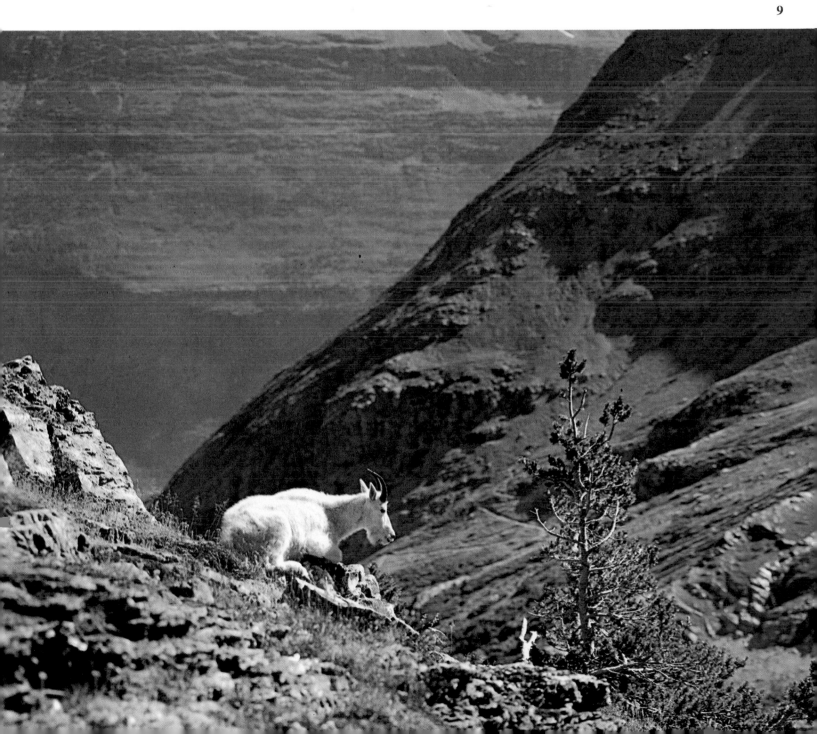

13

14

12

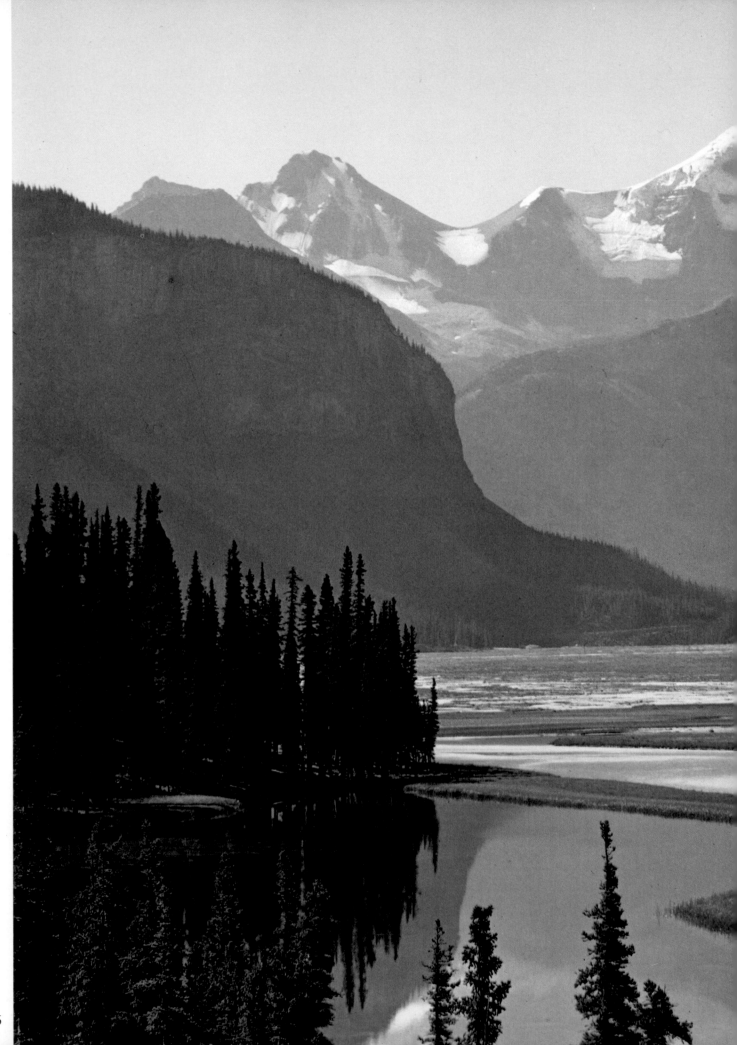

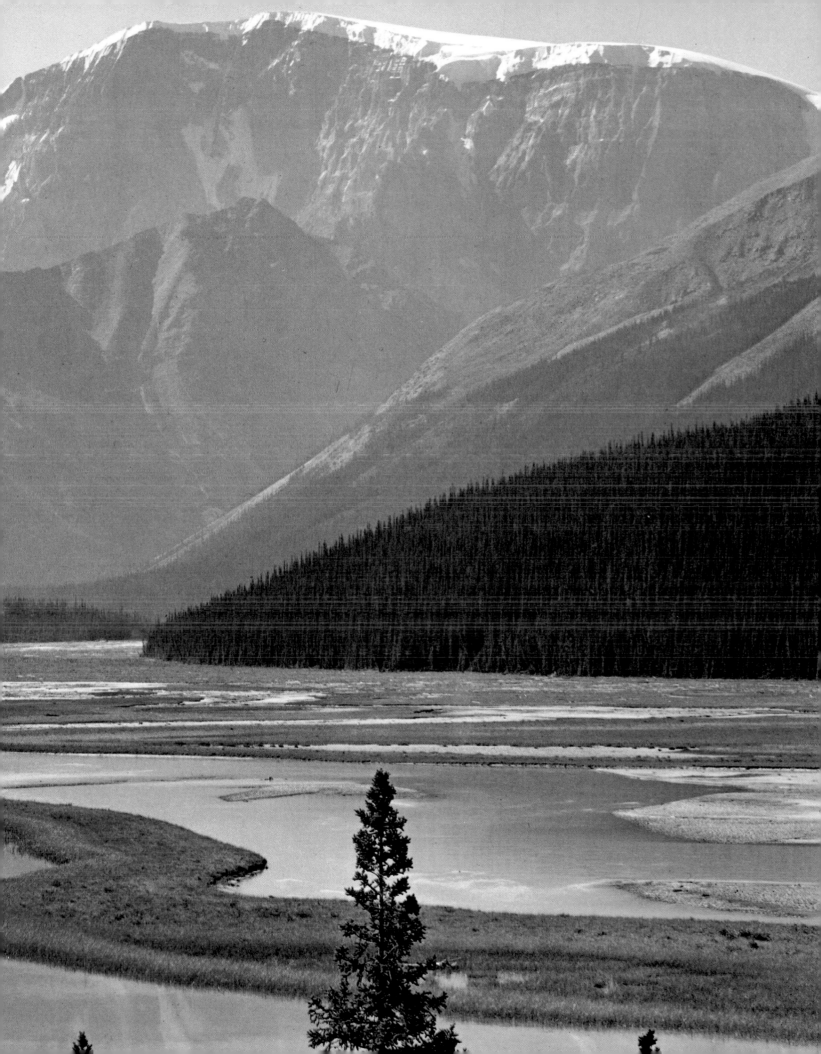

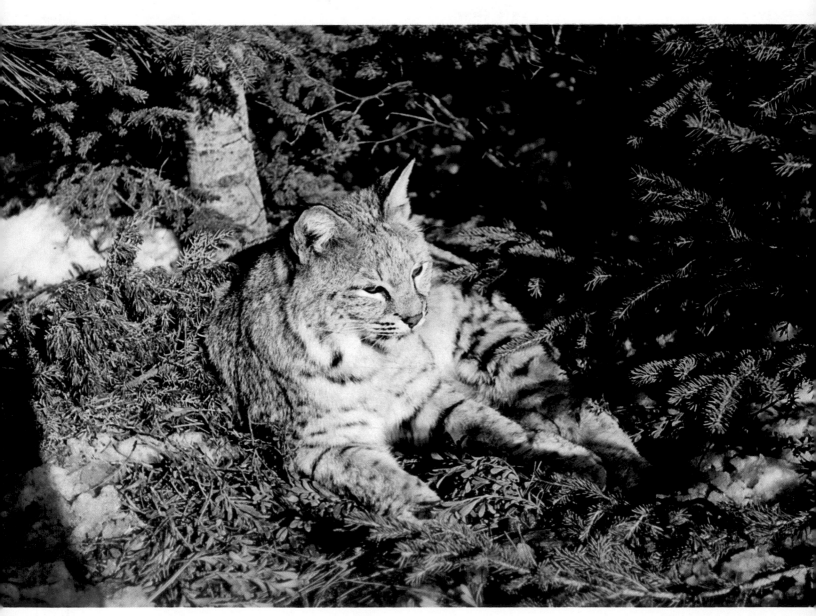

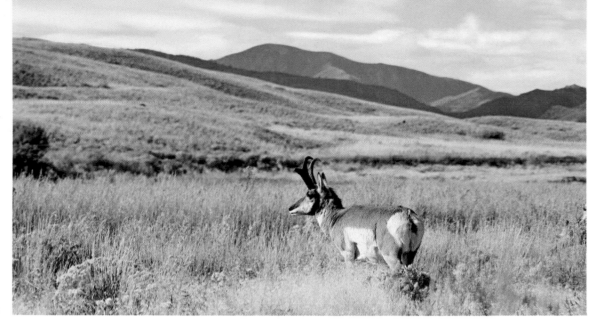

18

19

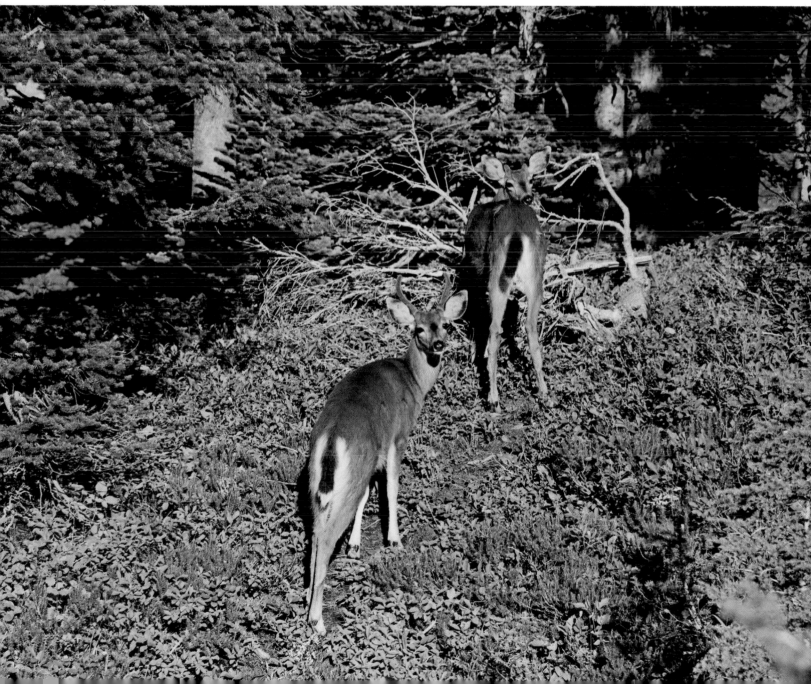

20

21

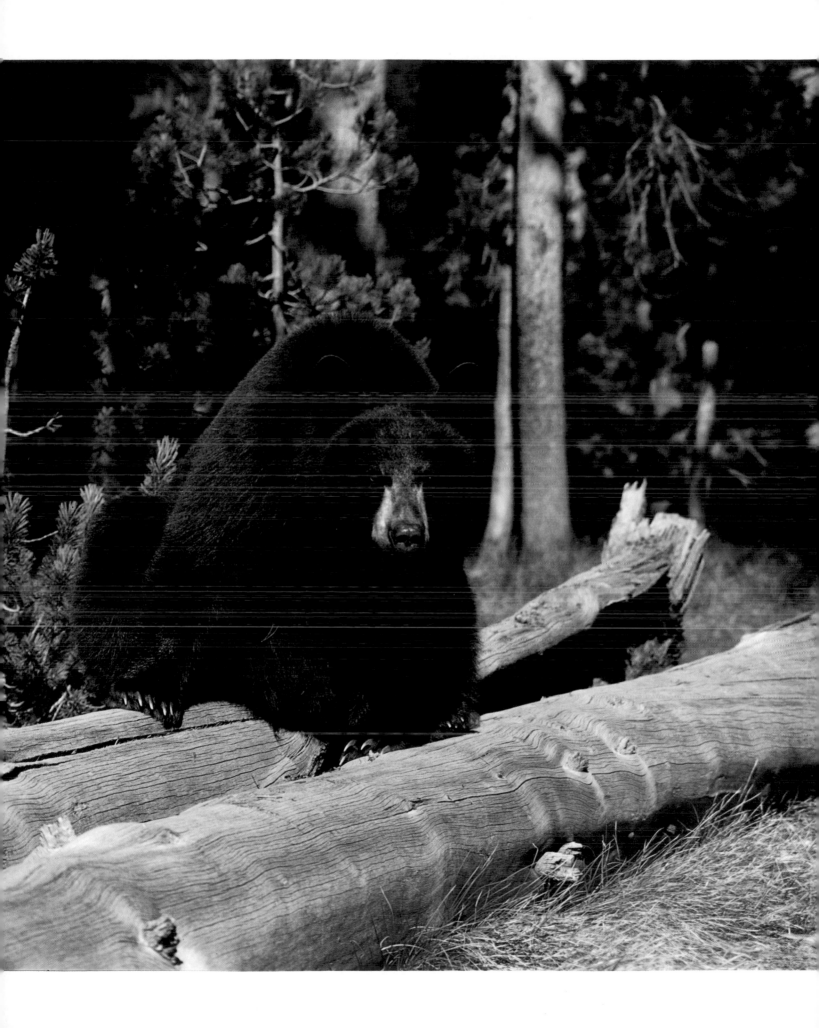

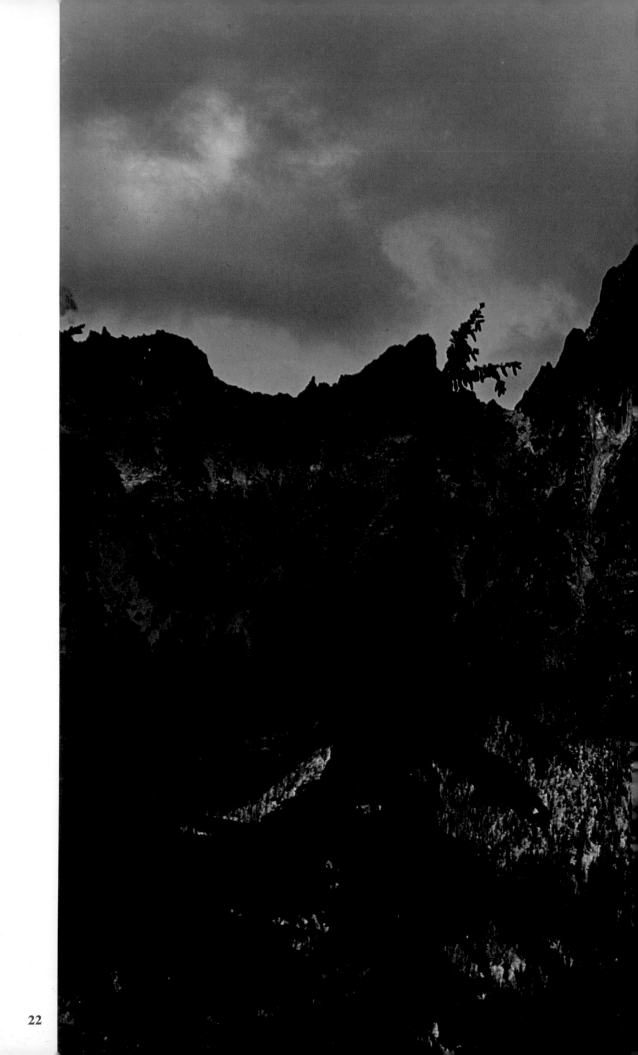

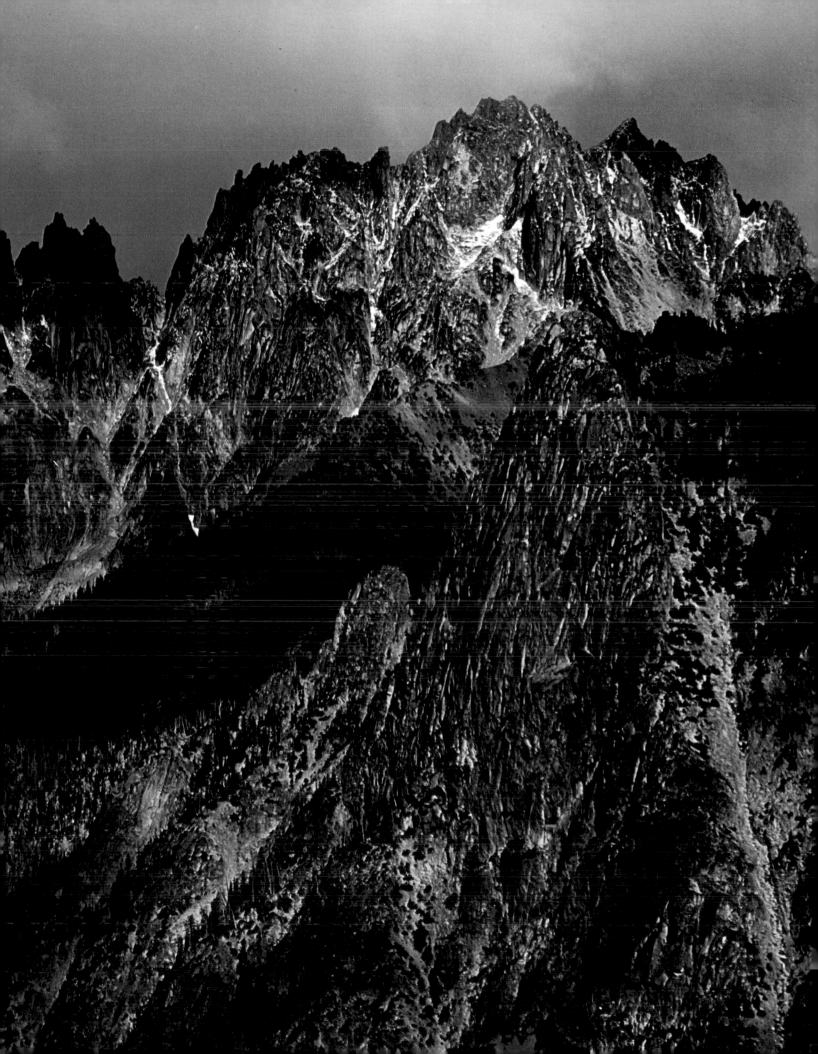

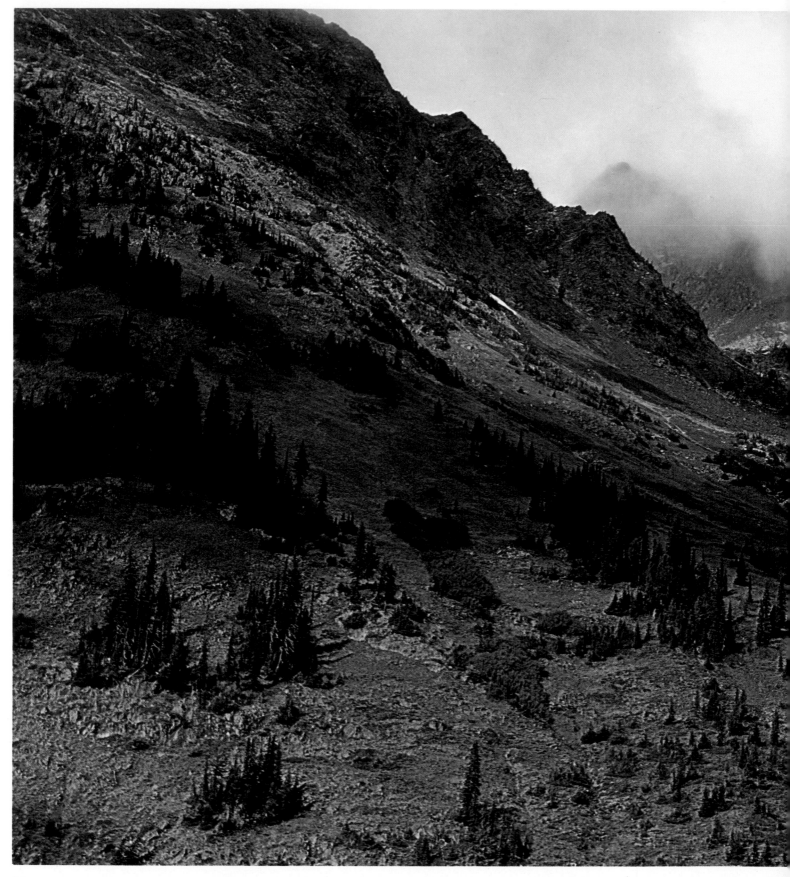

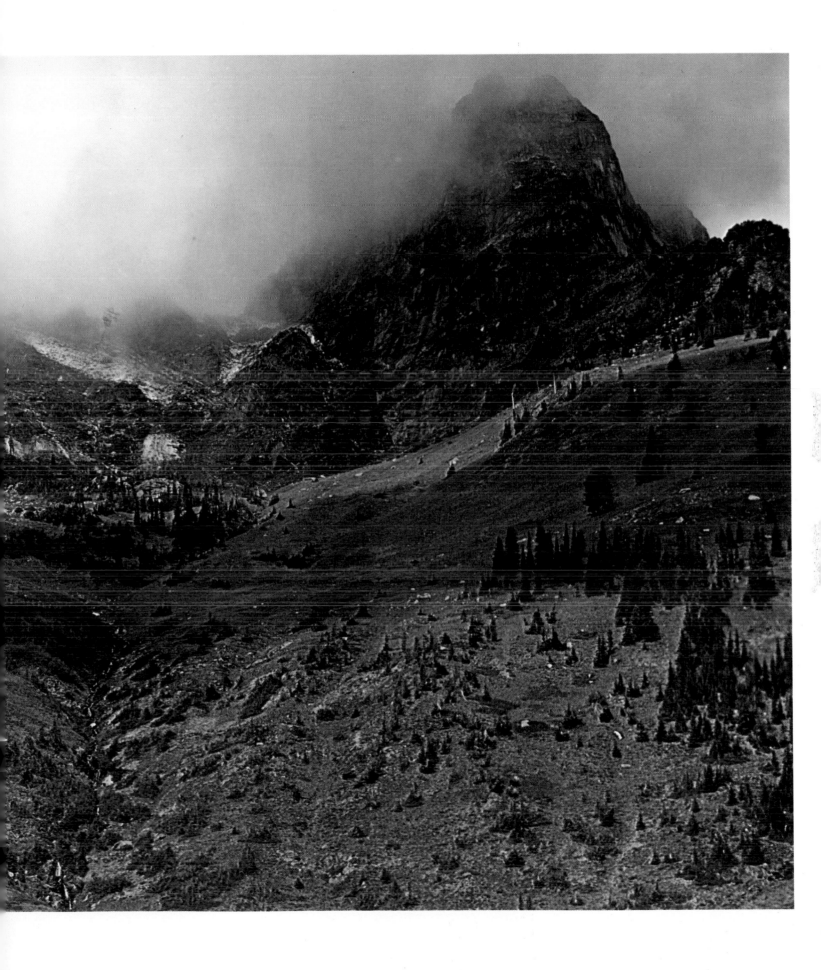

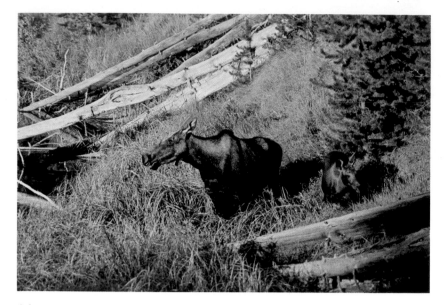

24

25

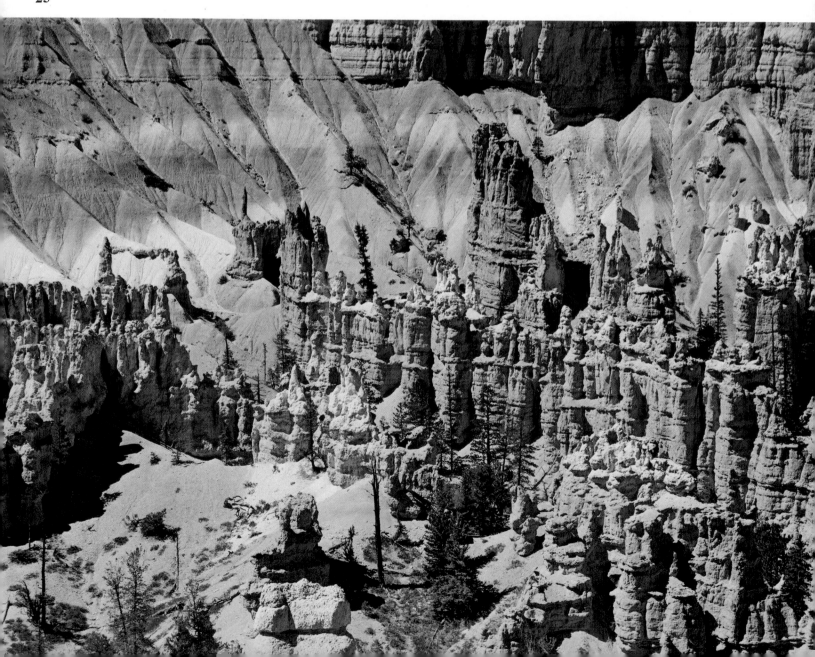

26

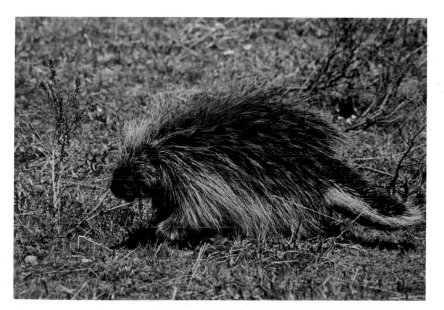

27

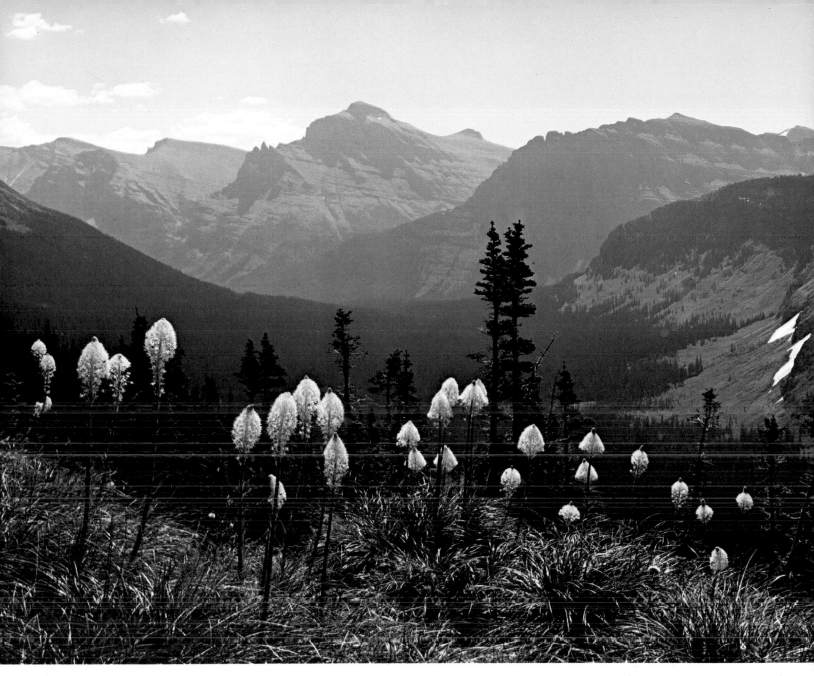

29

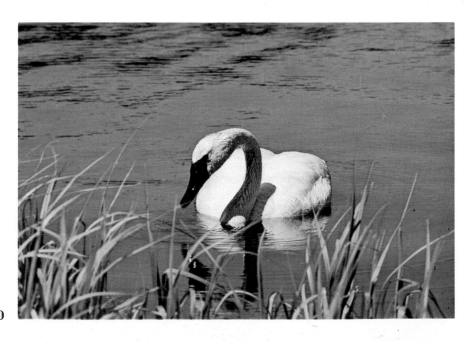

28 30

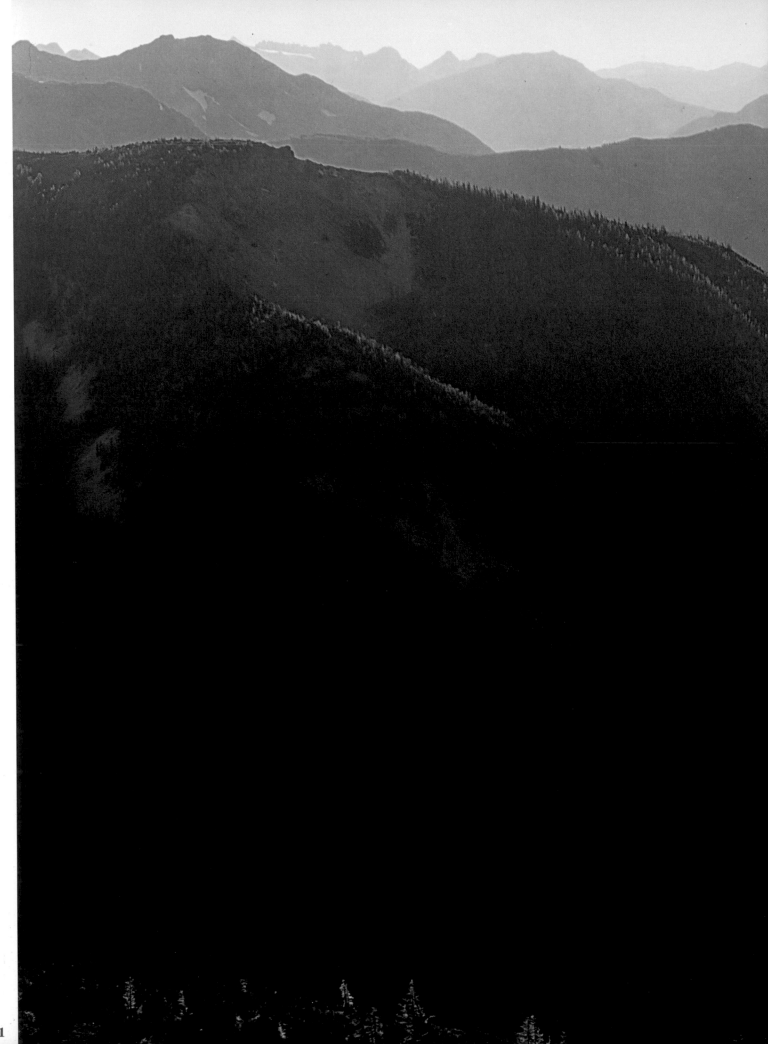

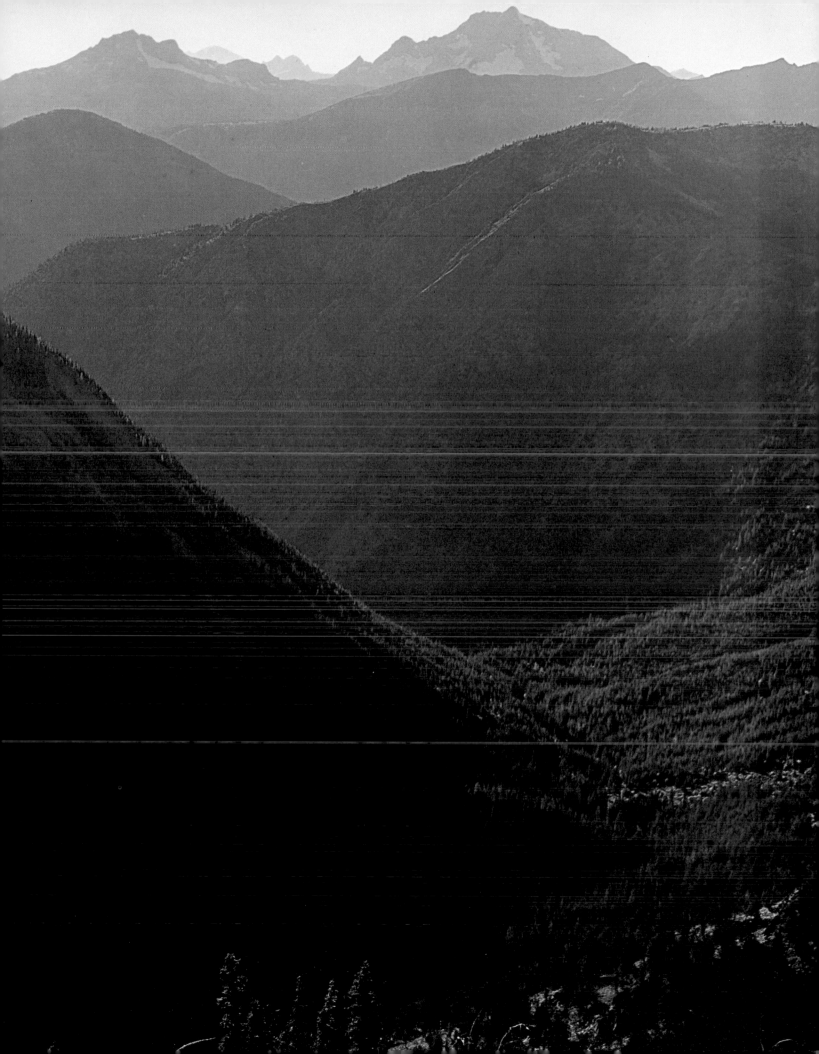

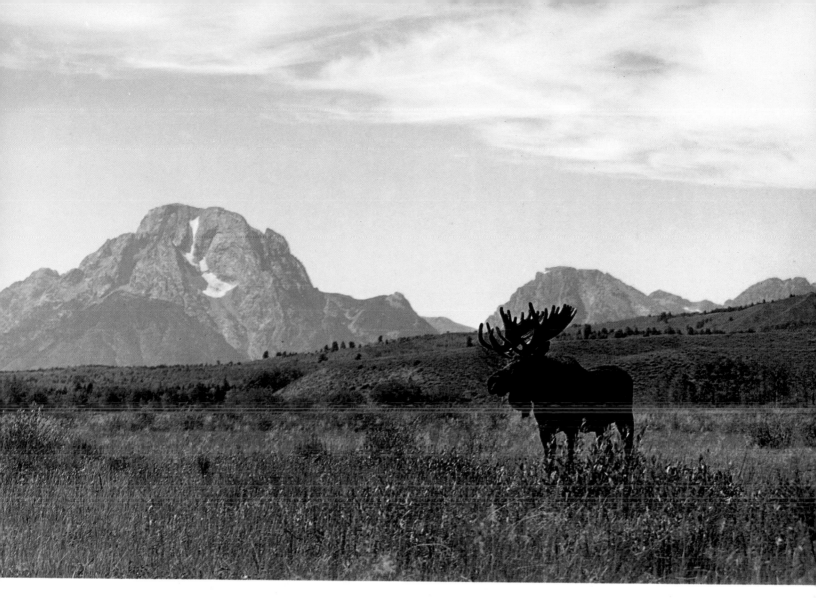

33

34

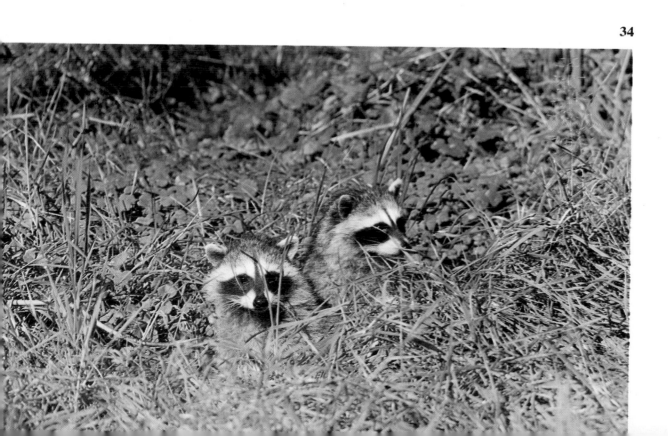

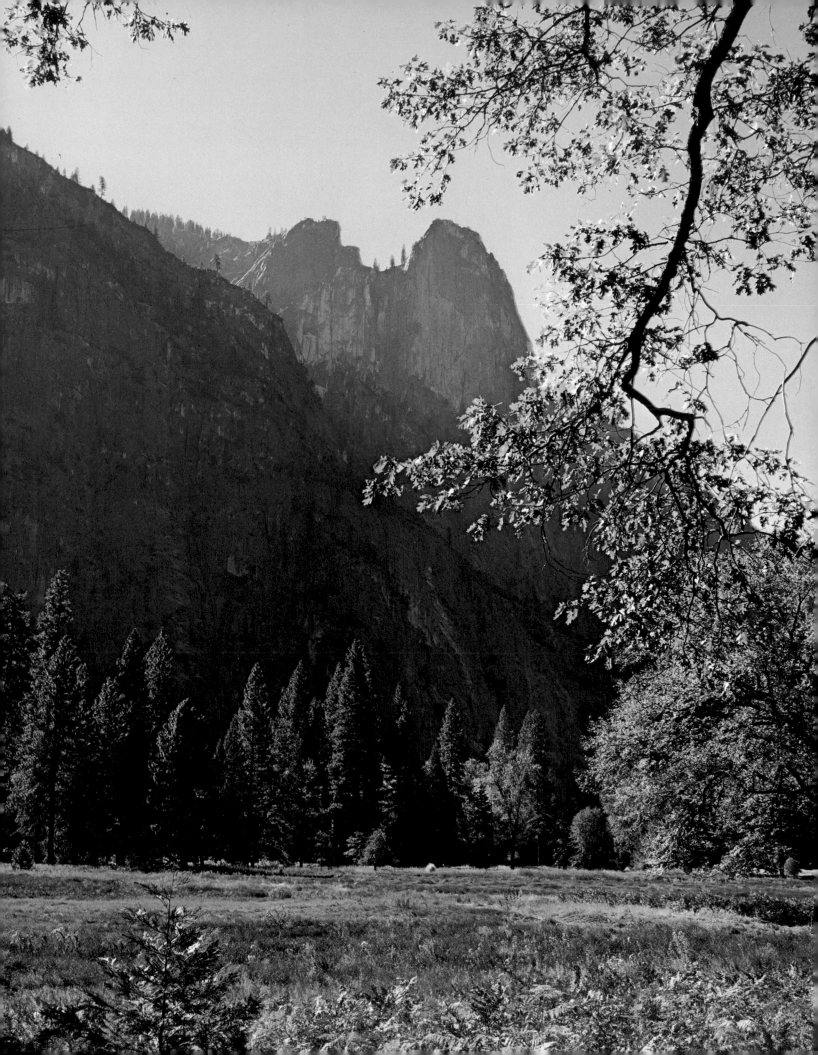

35

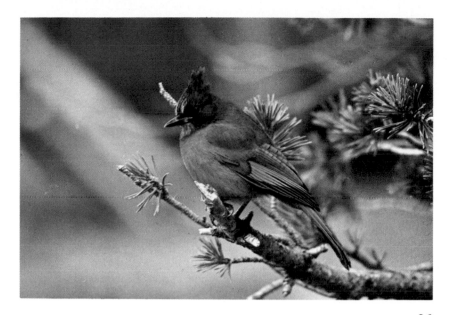

36

37

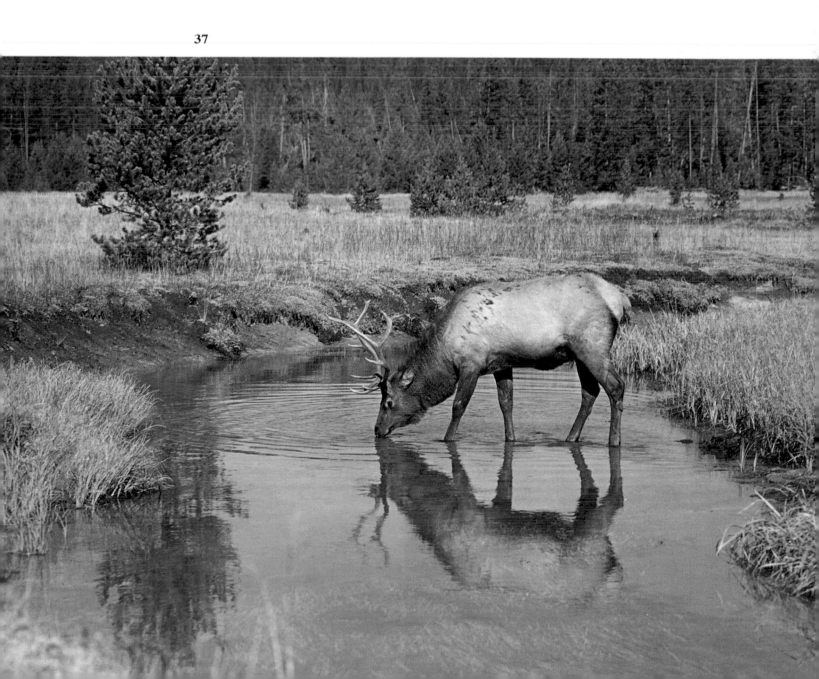

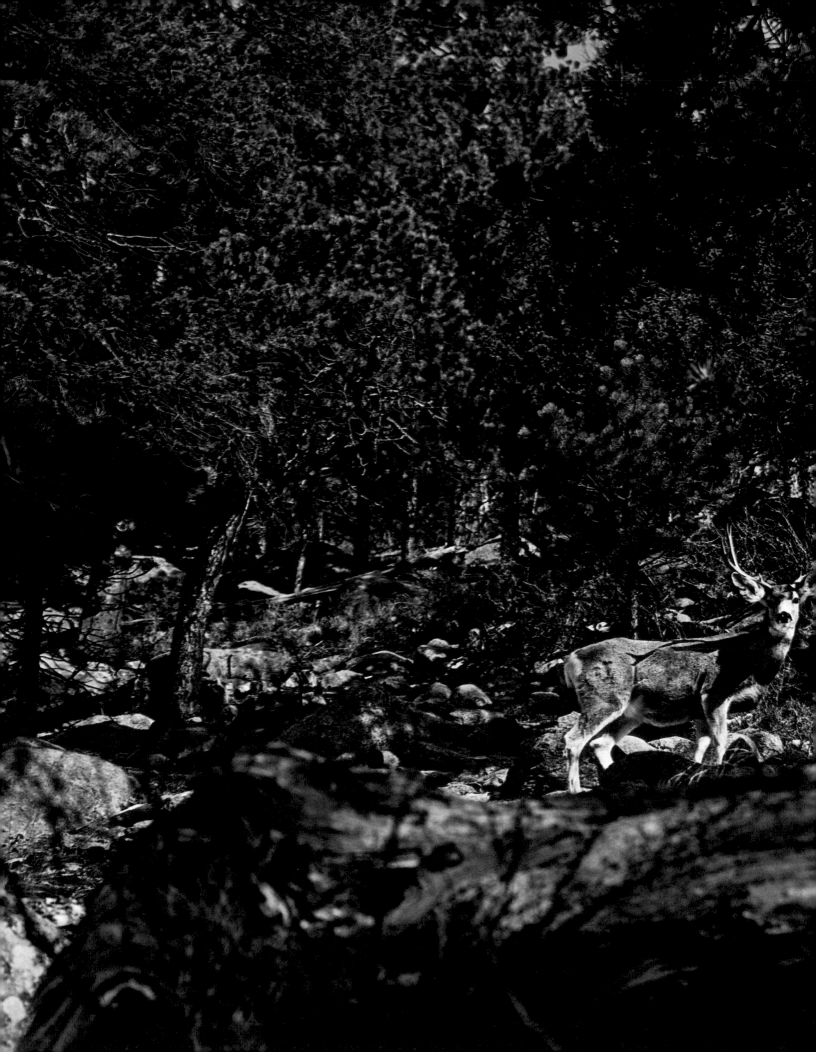

39

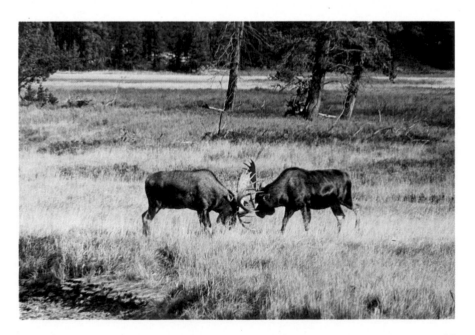

40 41

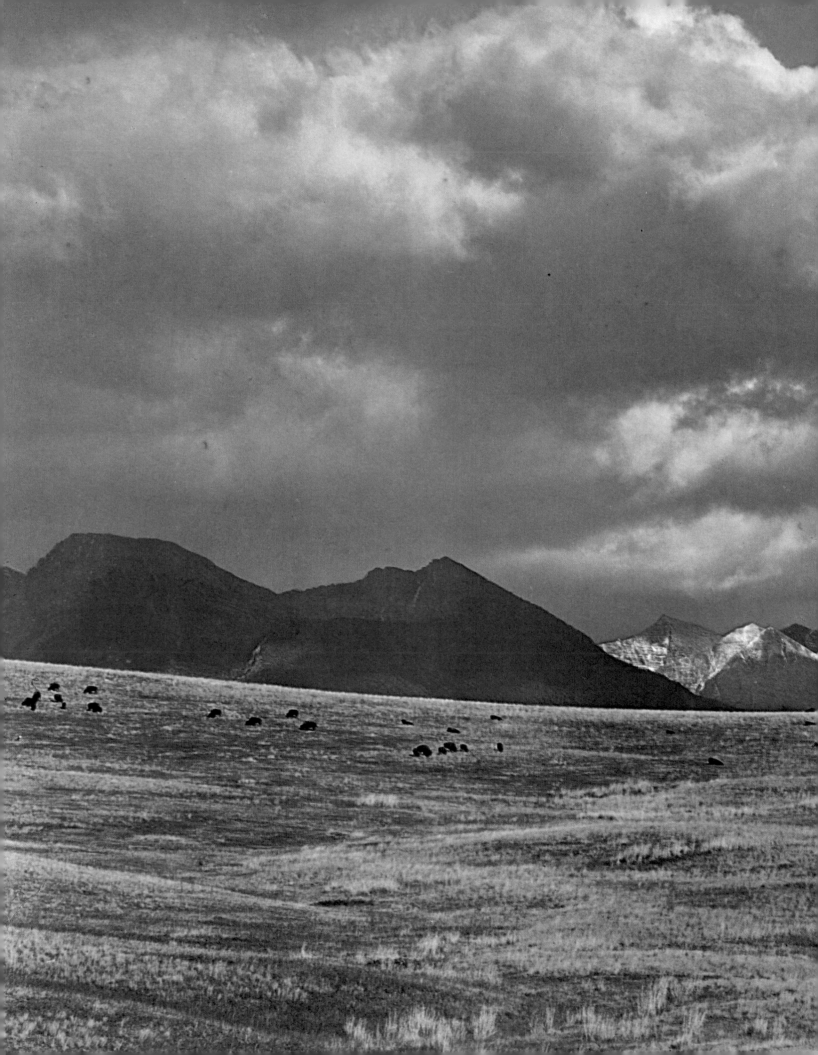

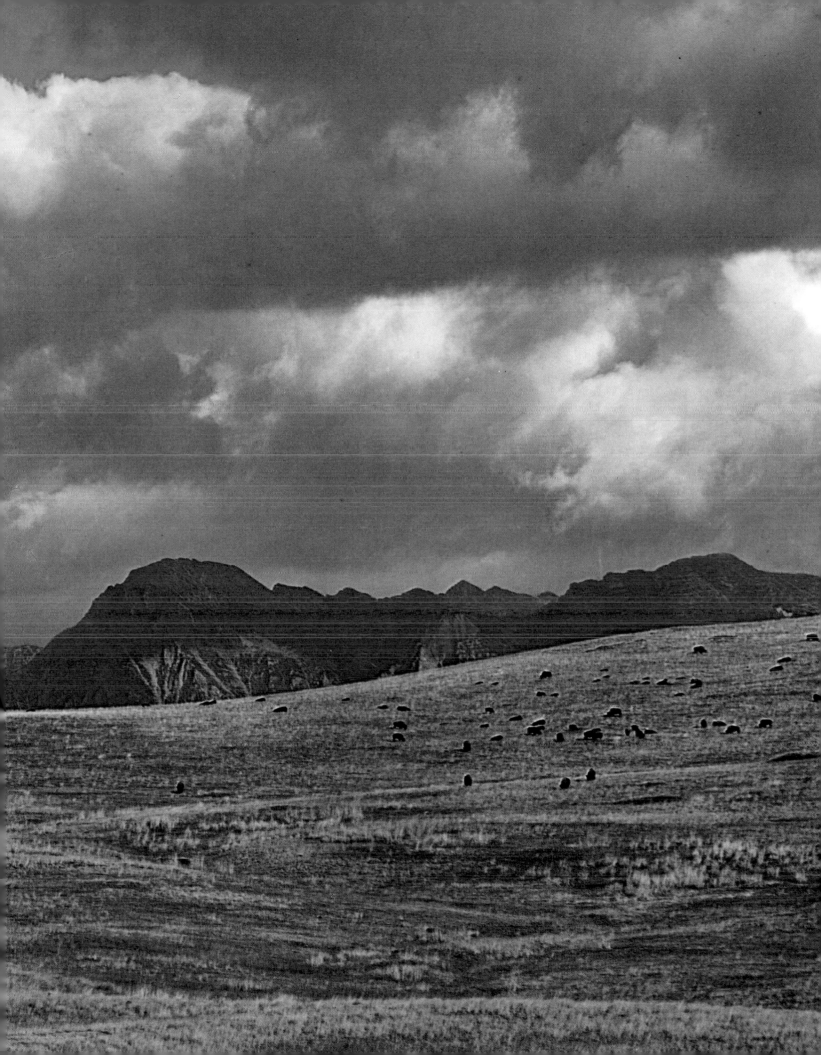

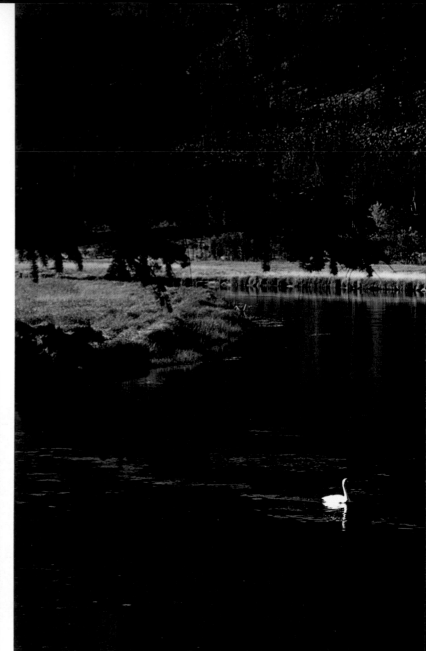

43

45

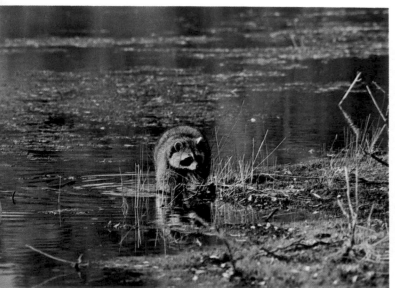

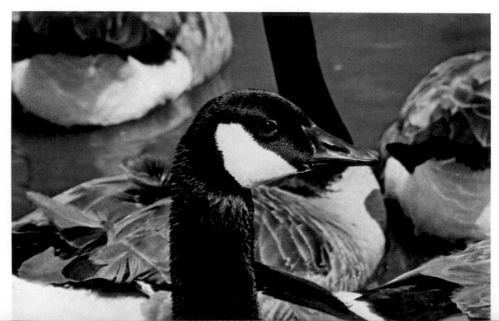

44

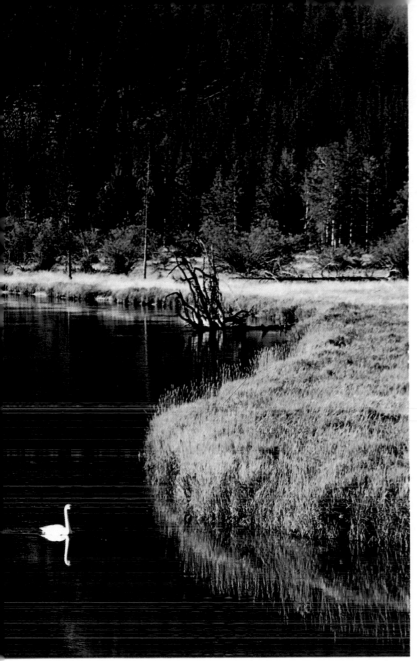

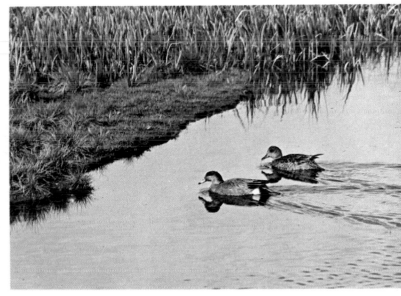

46

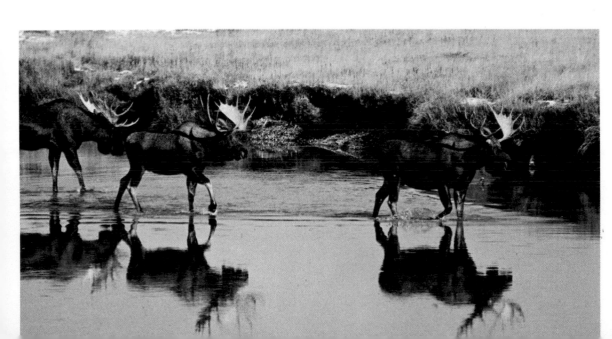

47

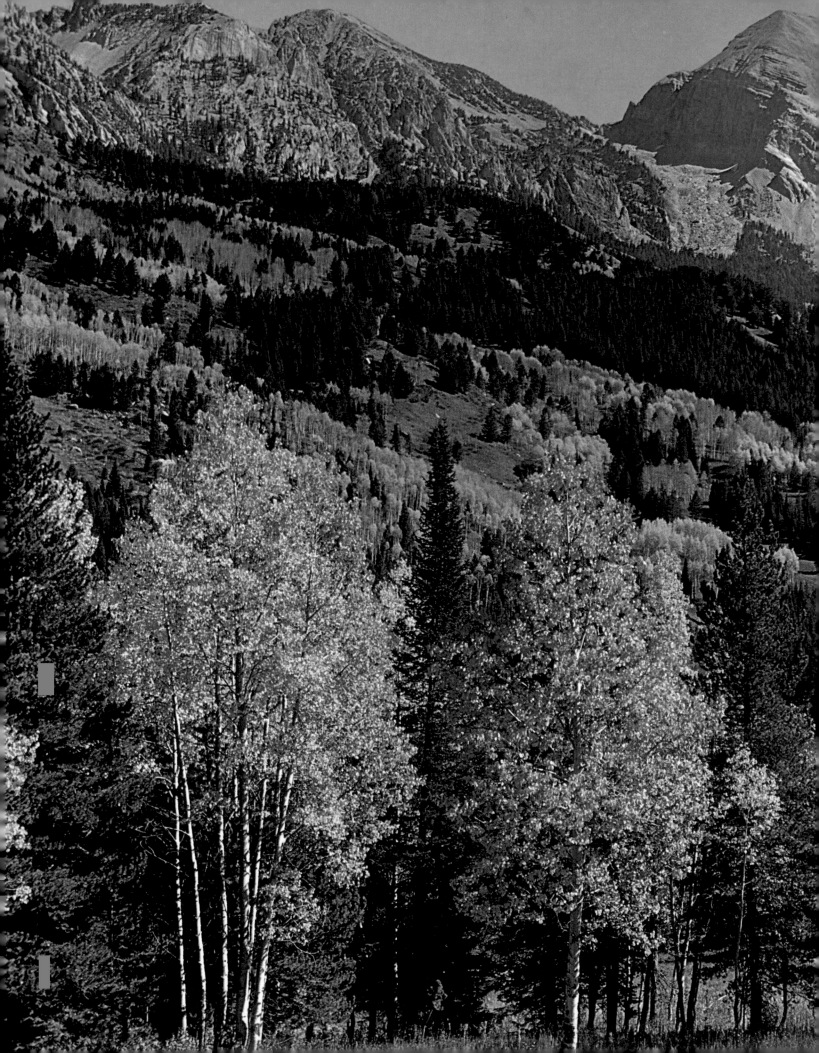

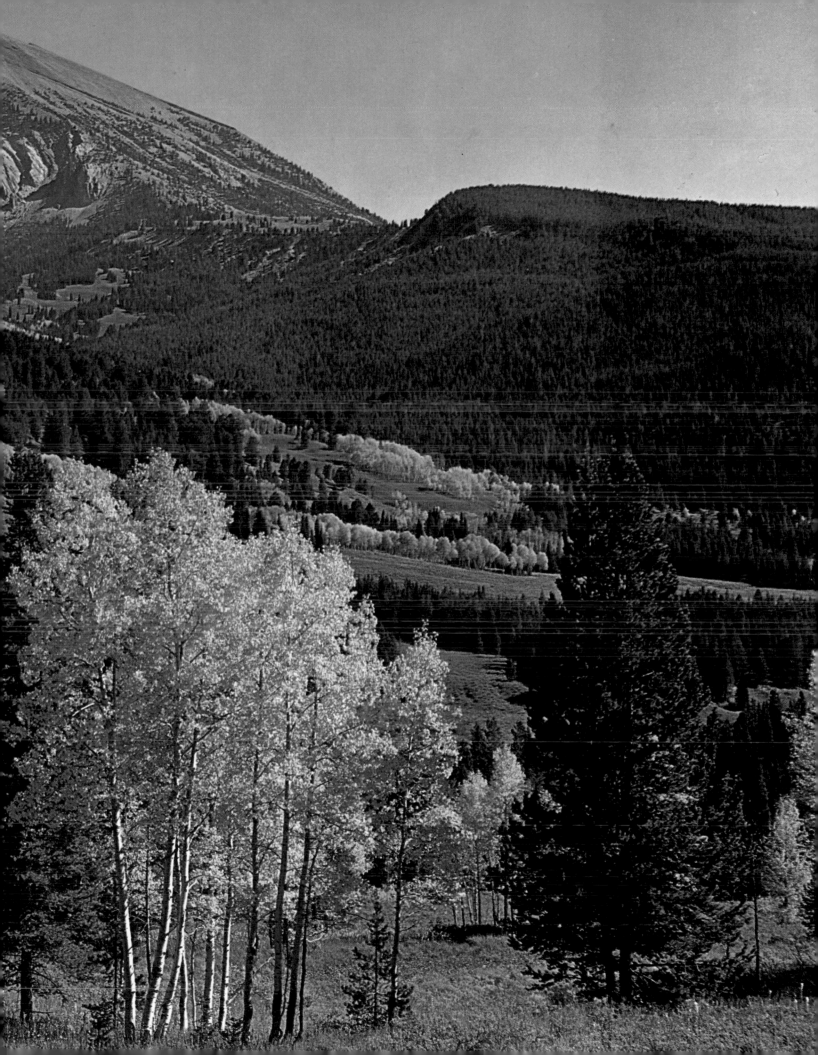

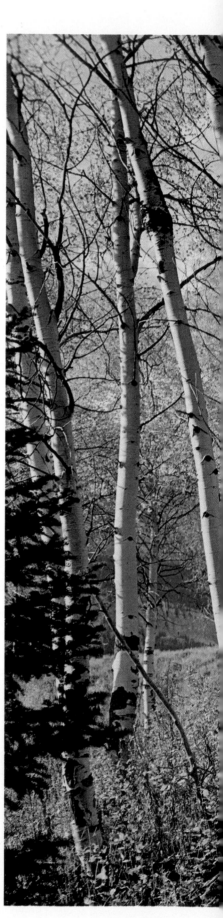

49 50

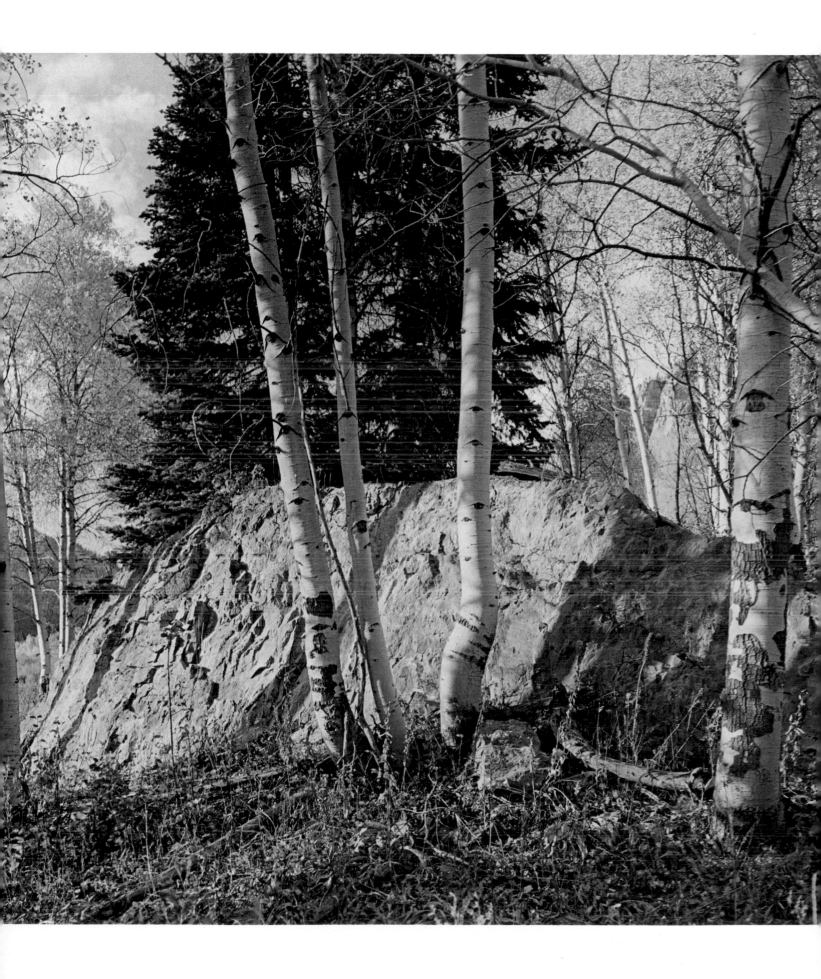

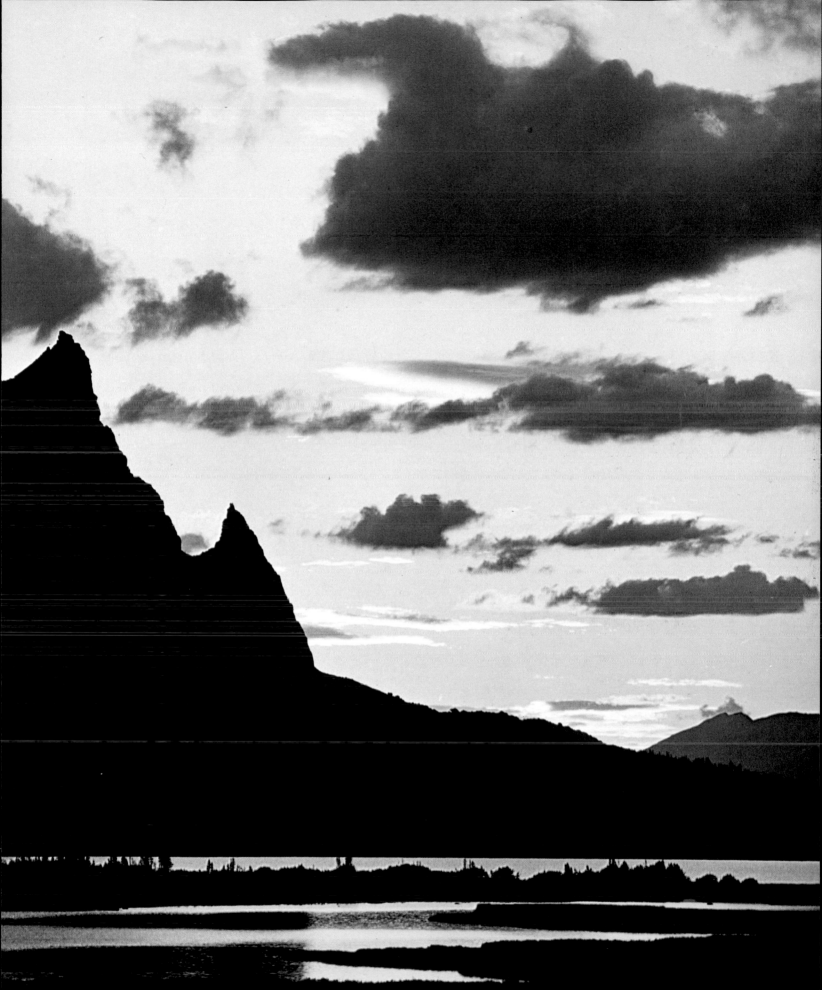

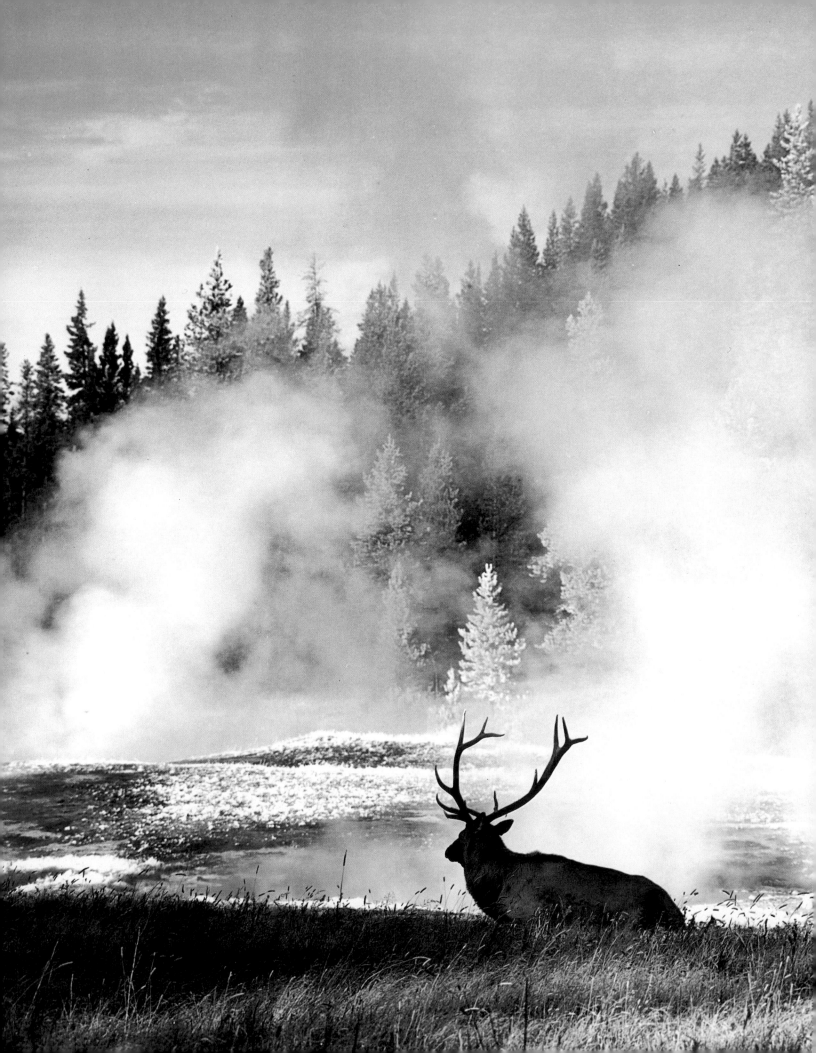

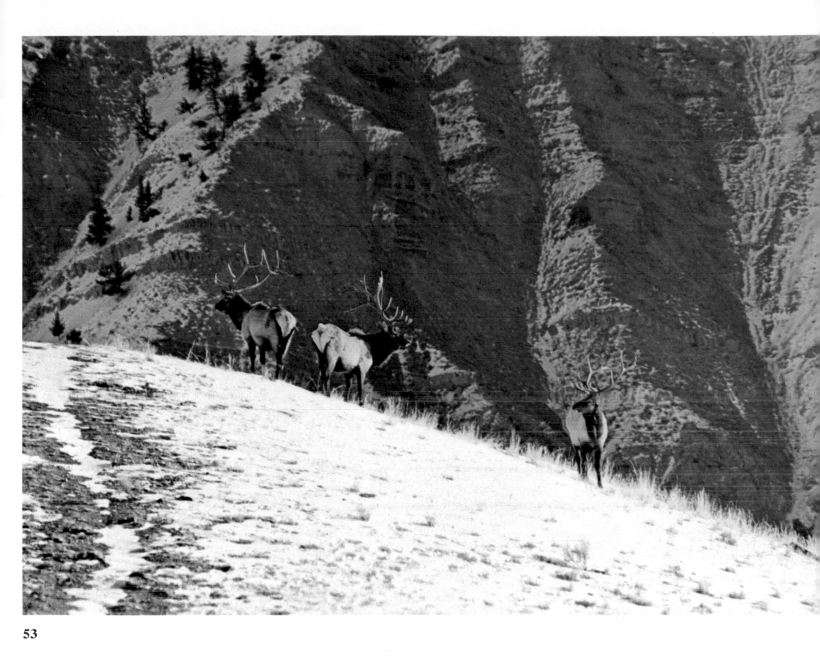

53

52 54

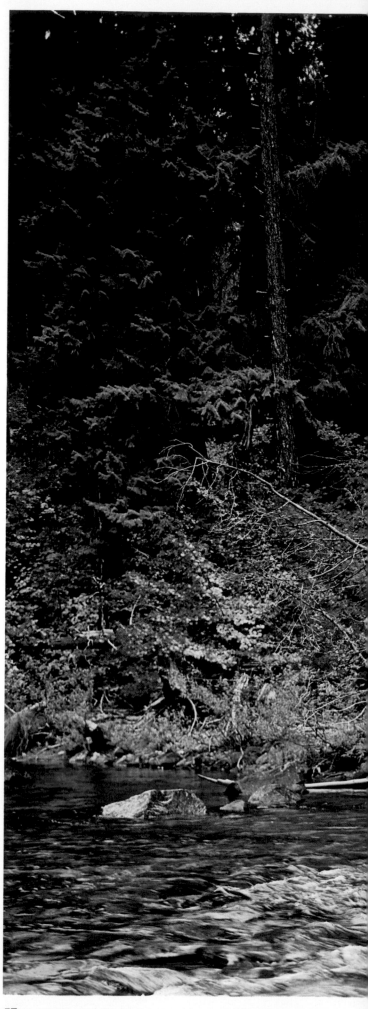

55

56

57

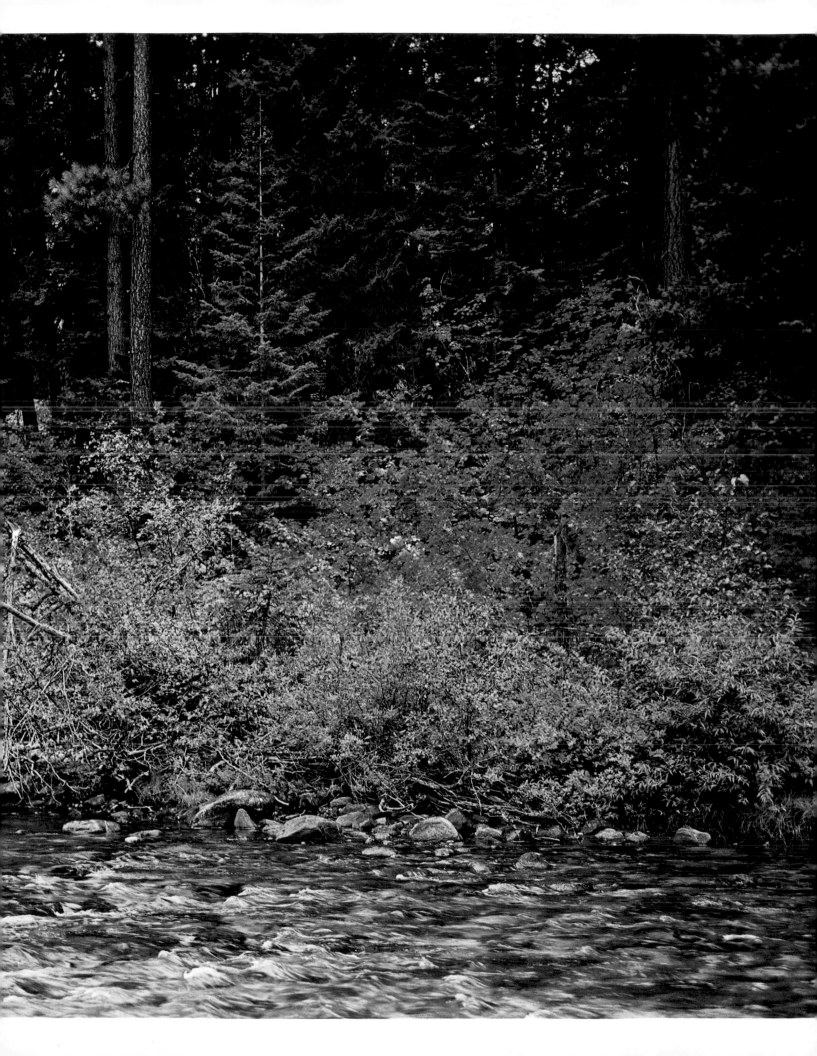

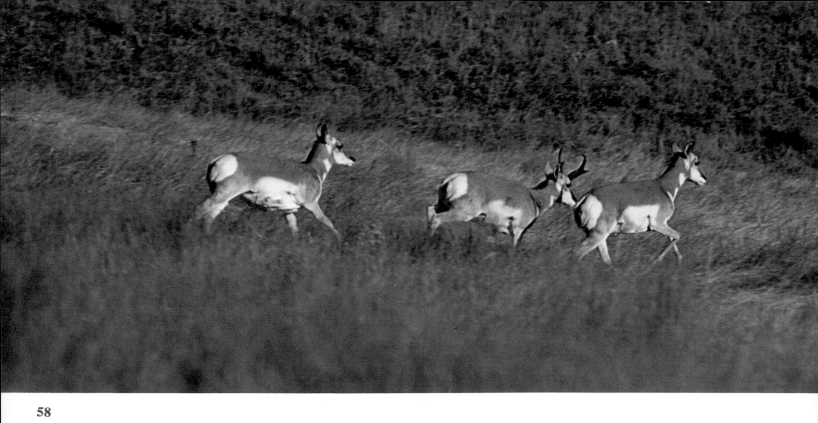

58

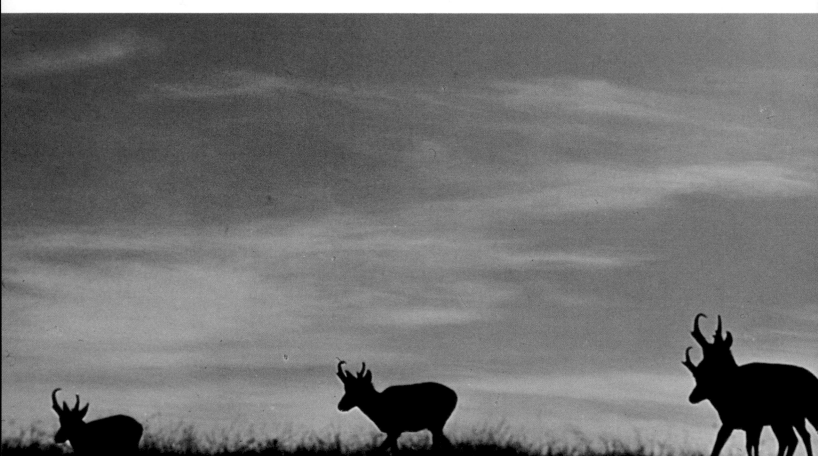

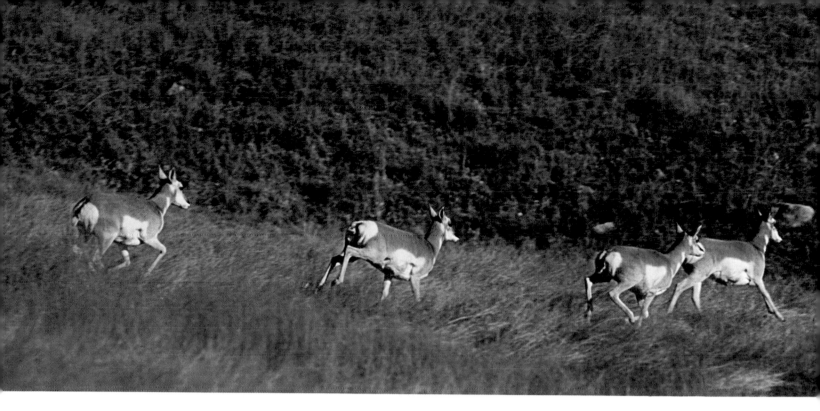

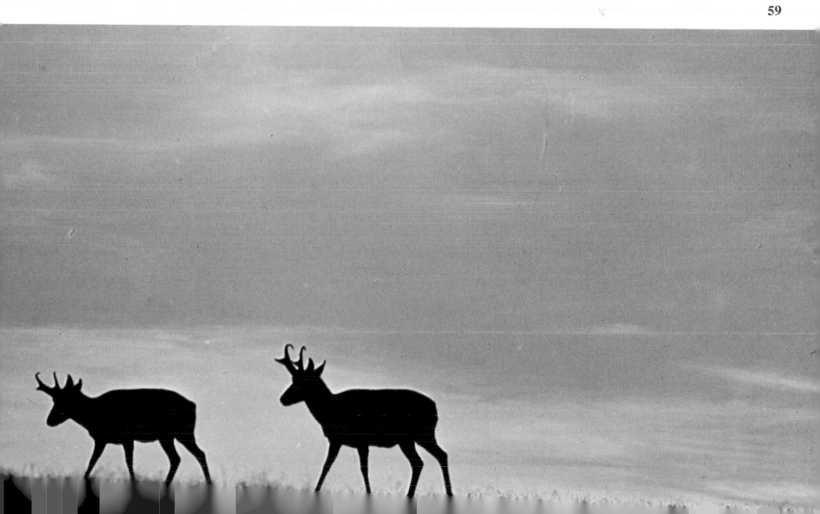

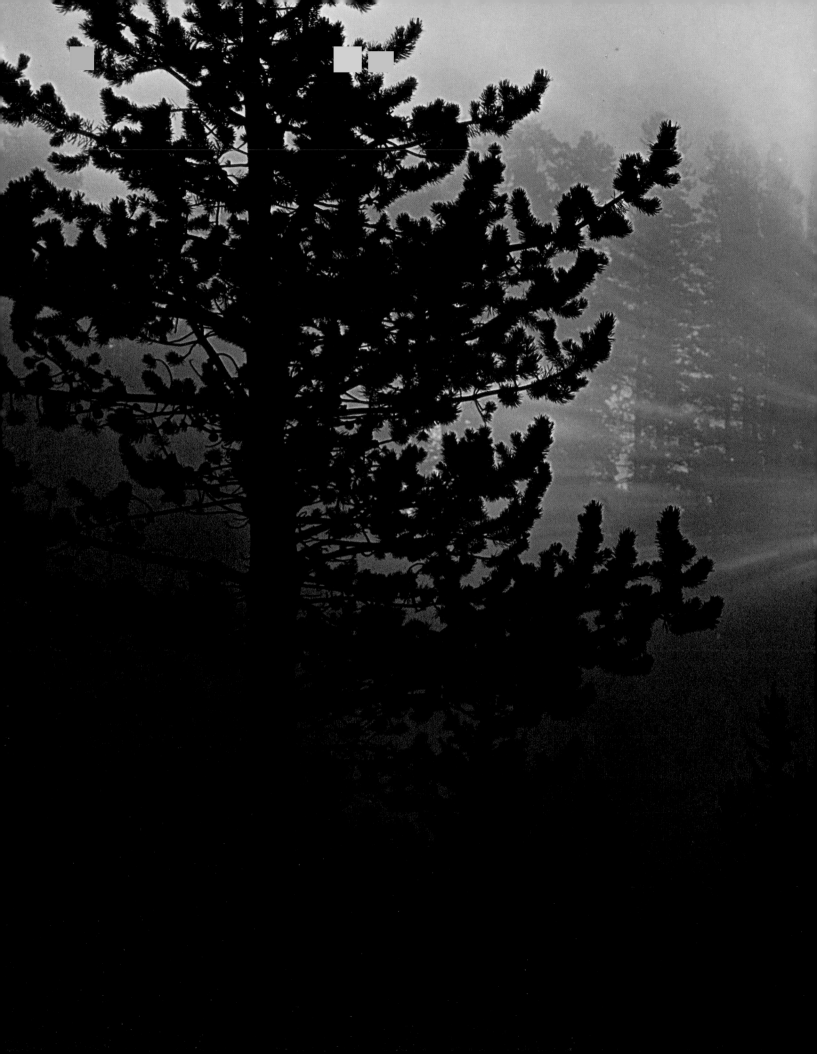

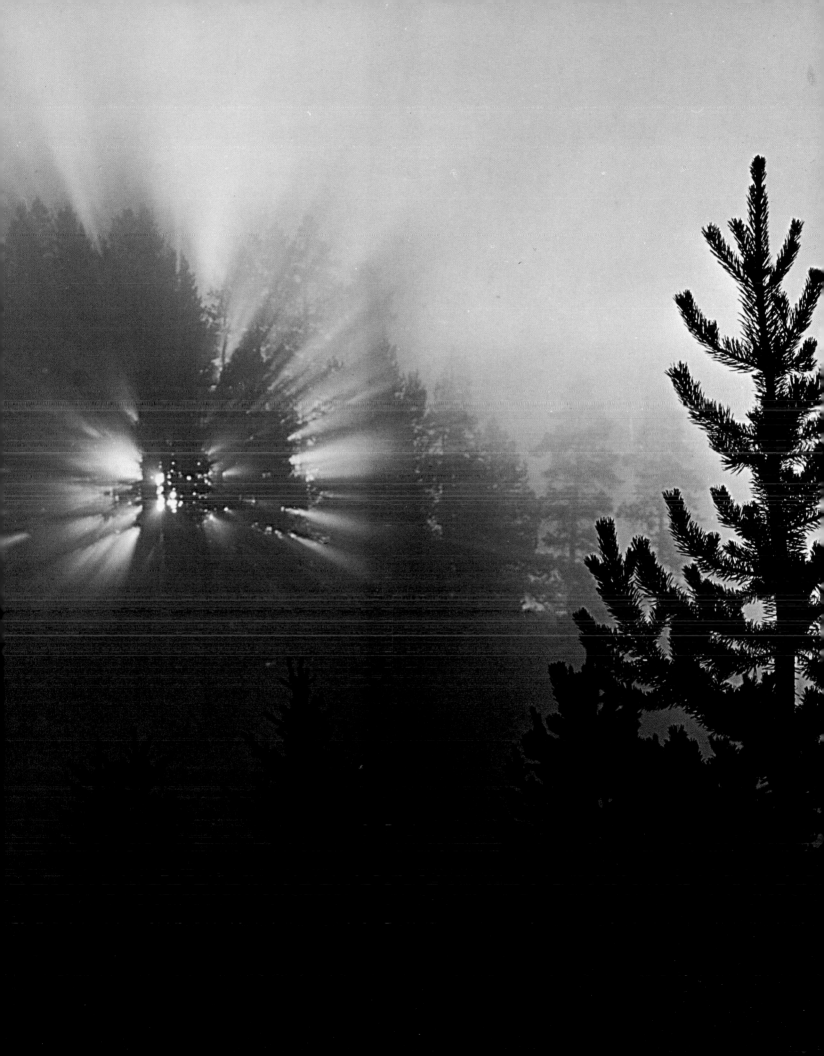

62

63

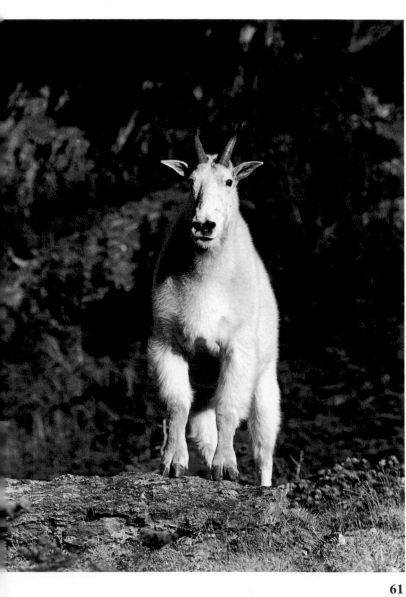

61

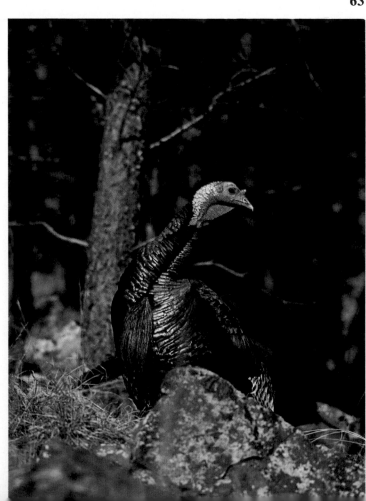

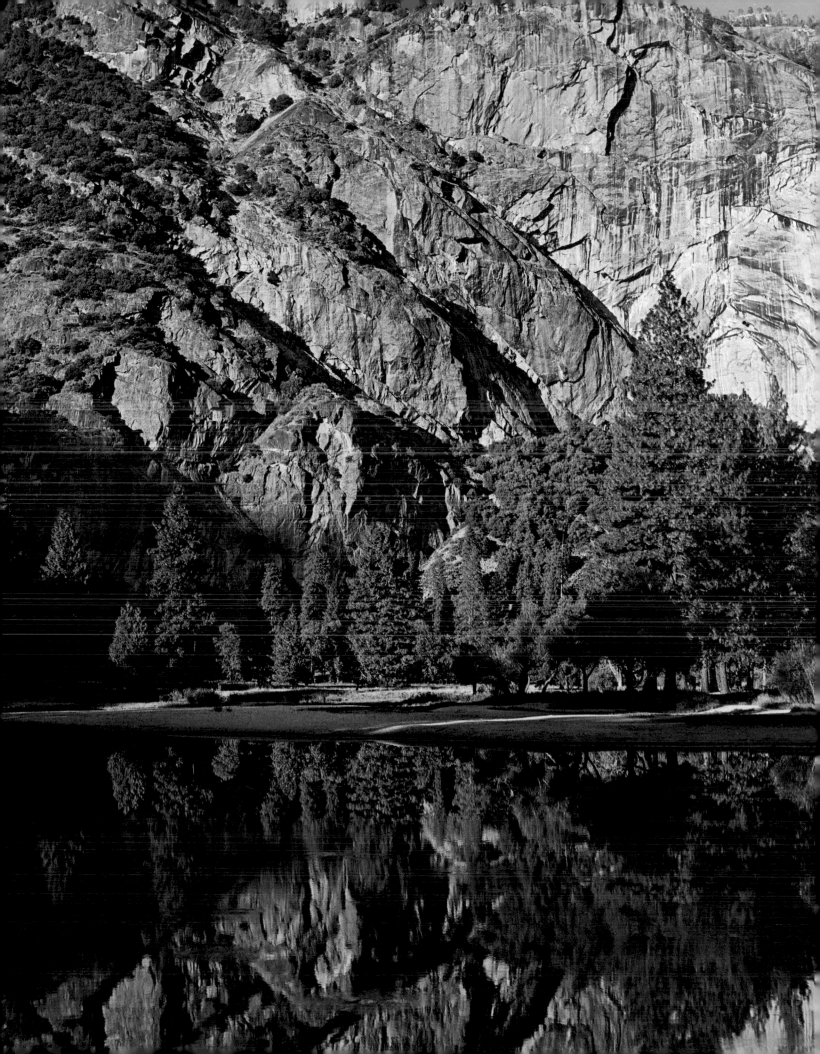

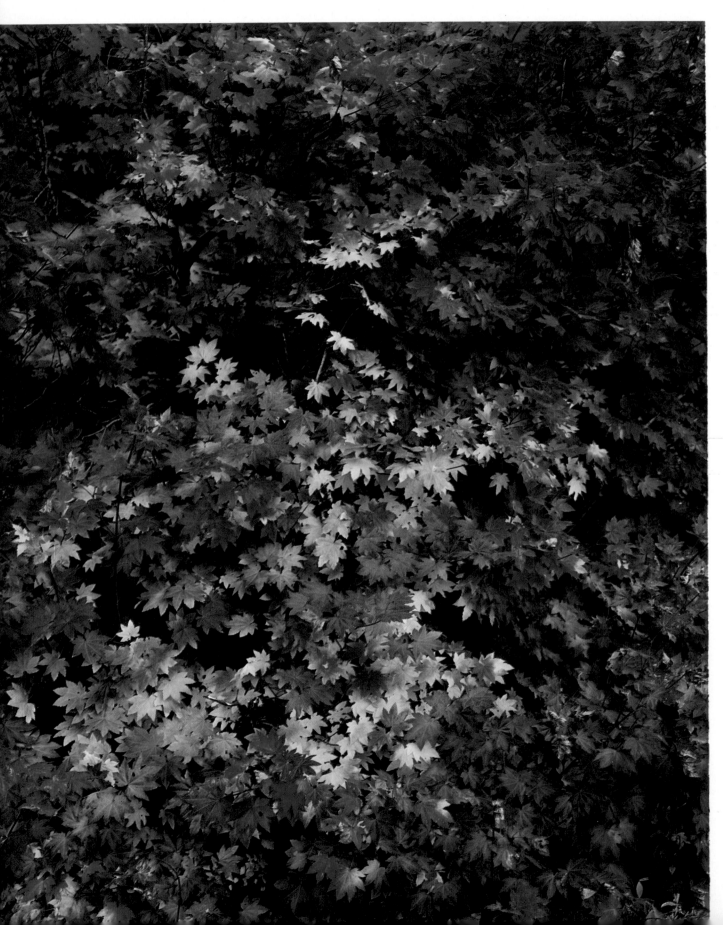

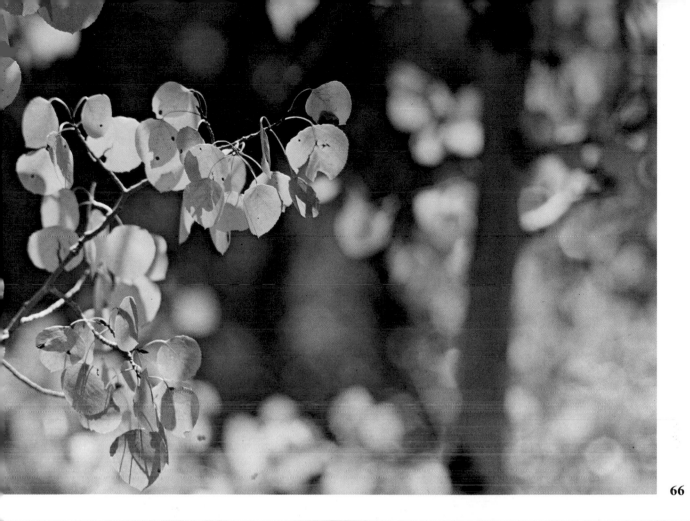

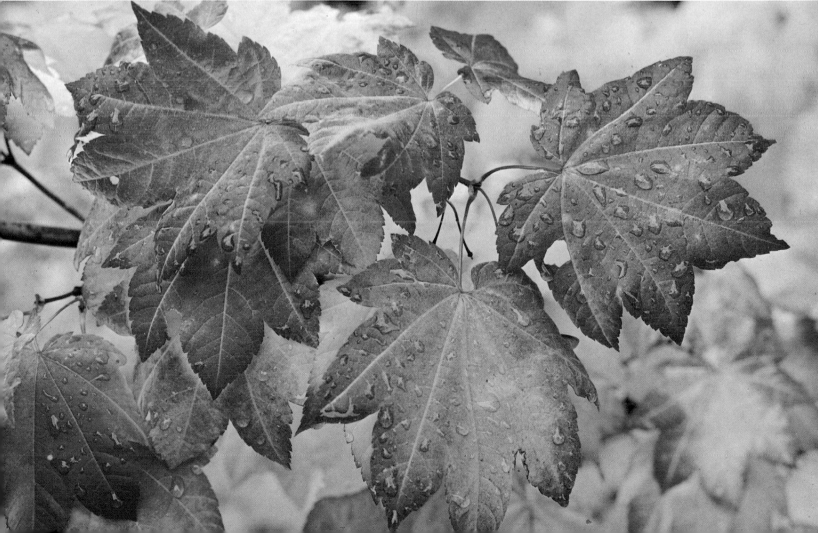

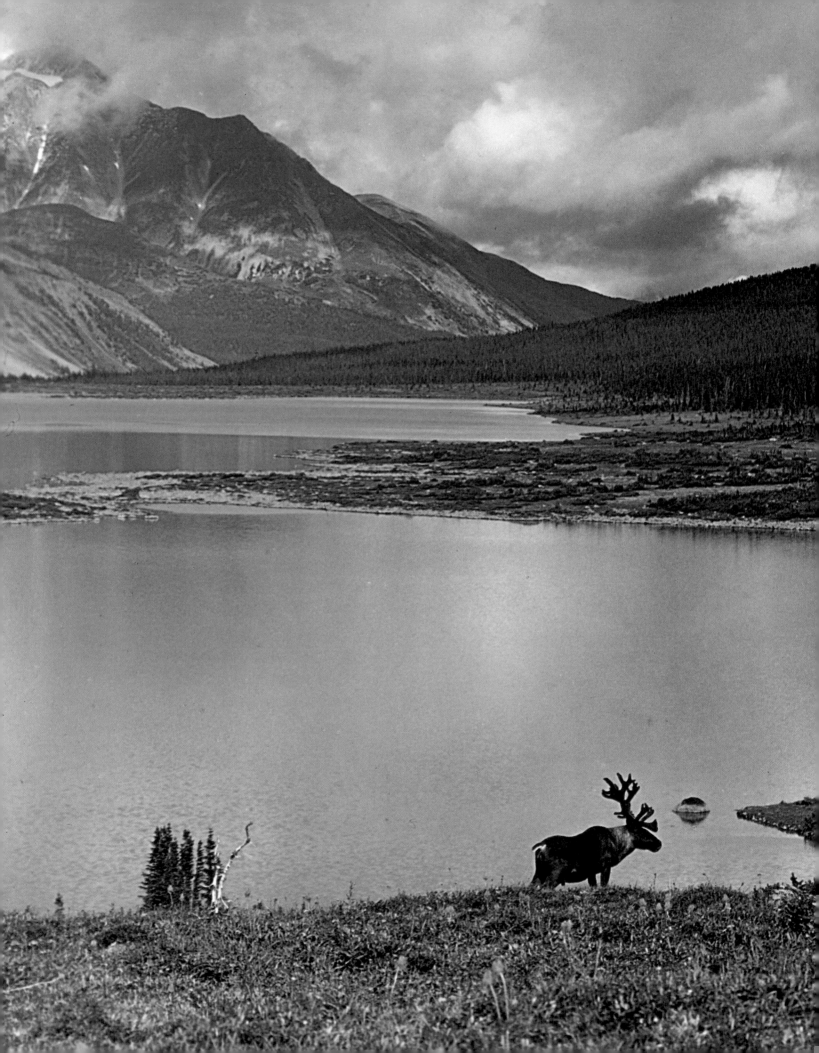

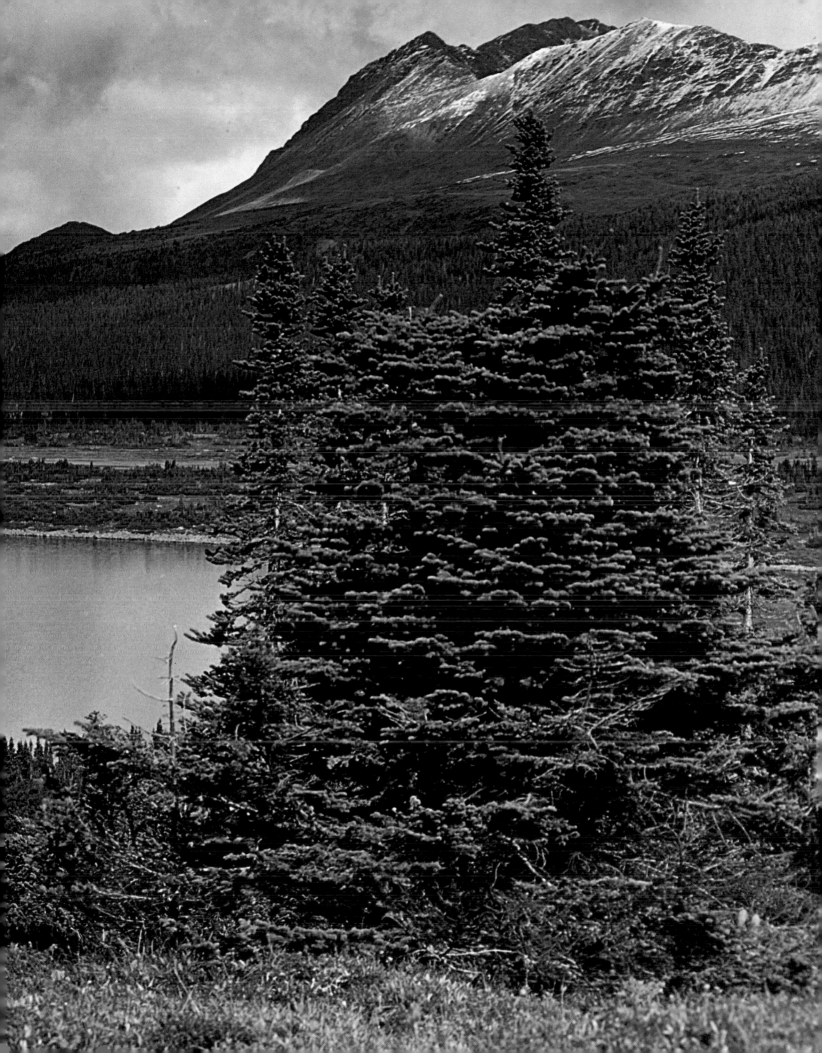

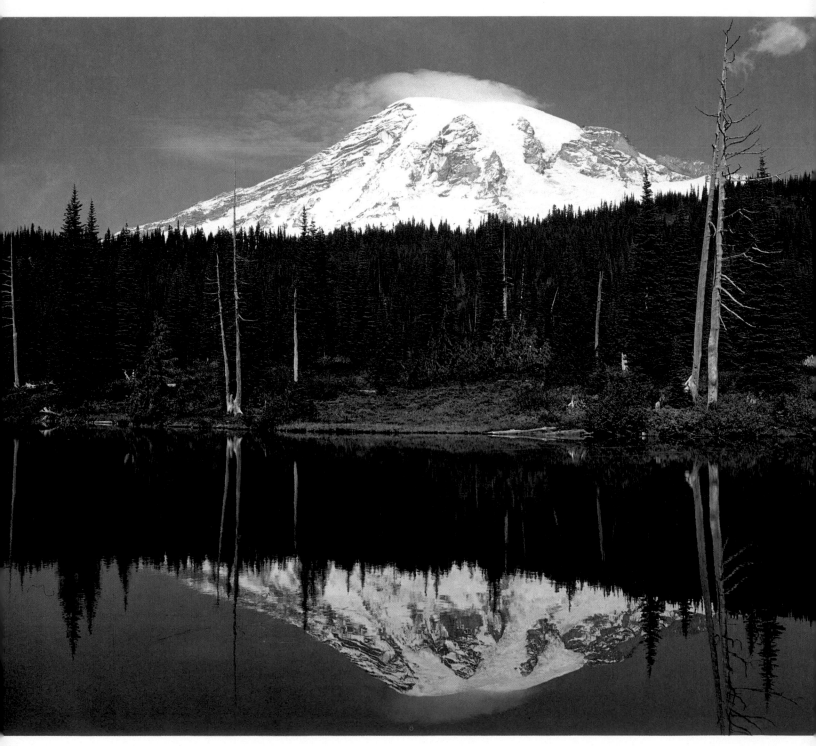

69

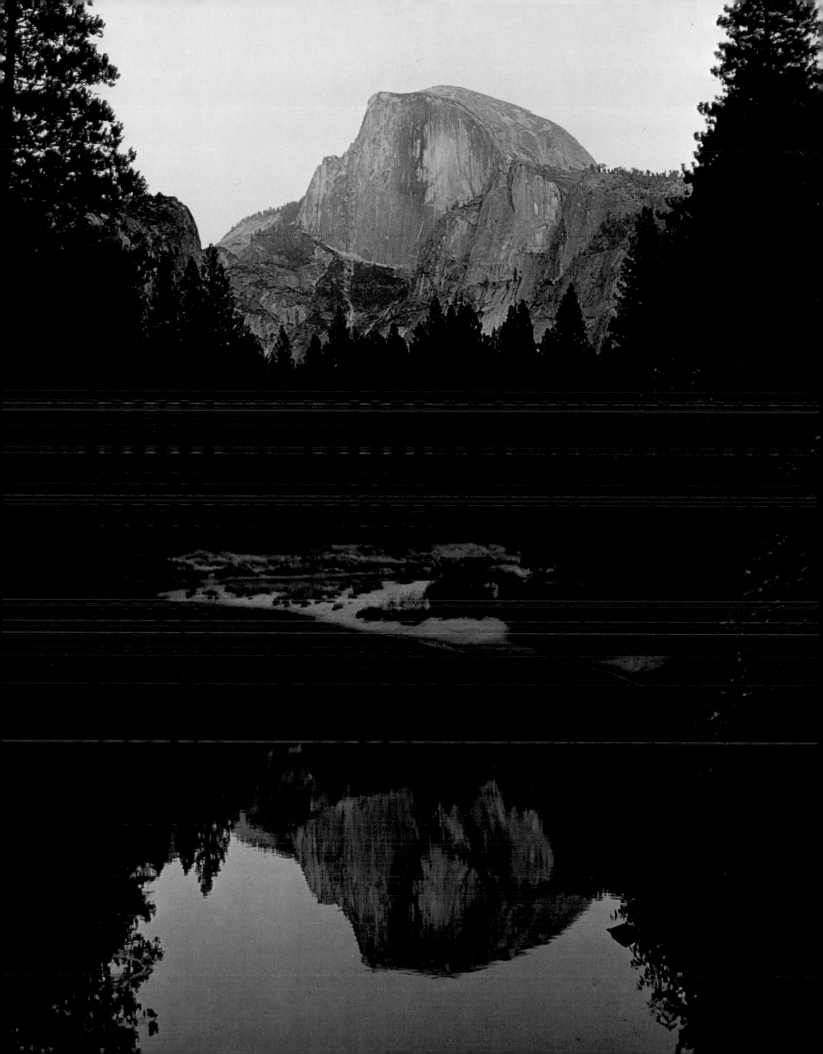

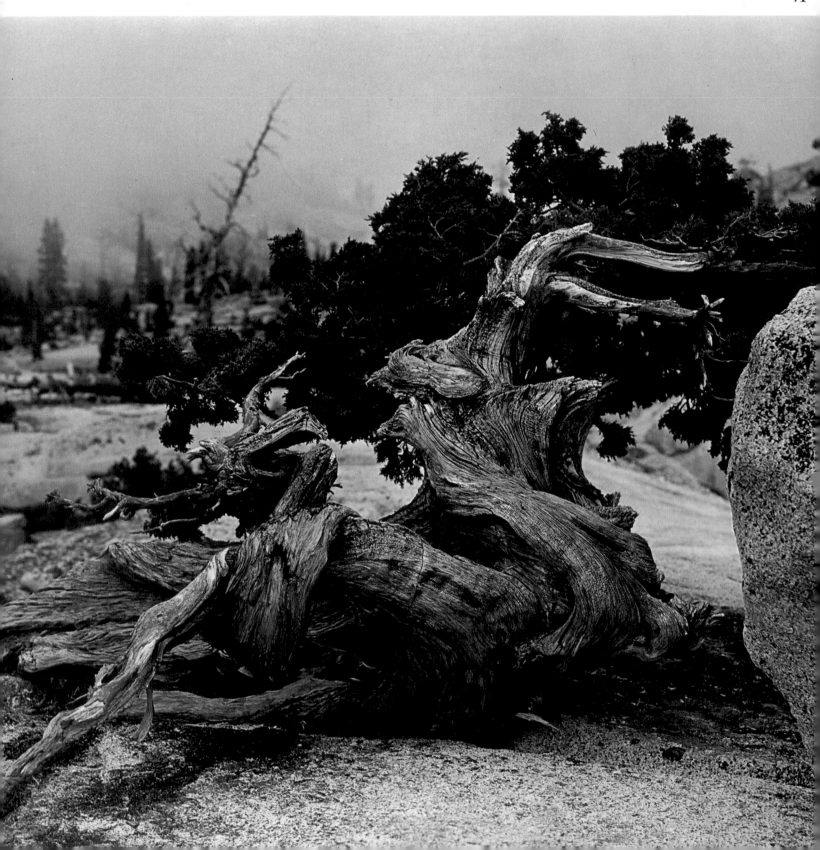

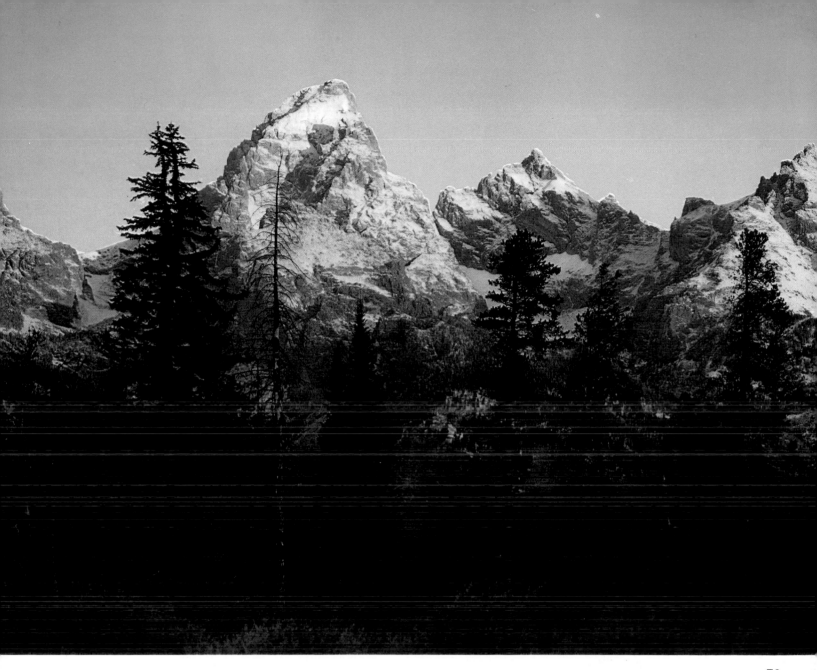

72

73

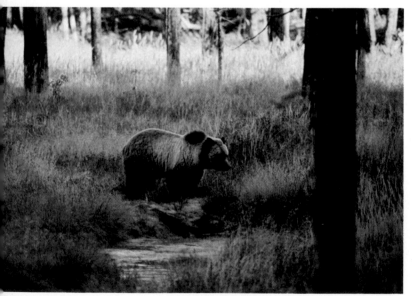

74

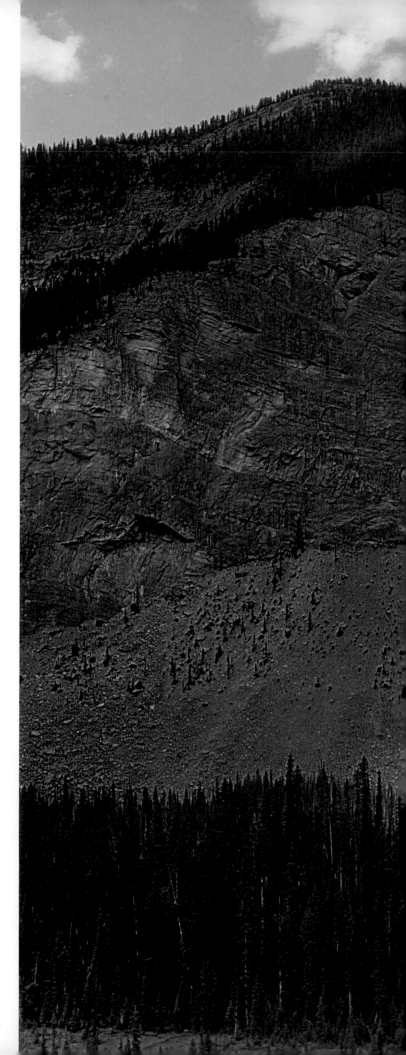

75

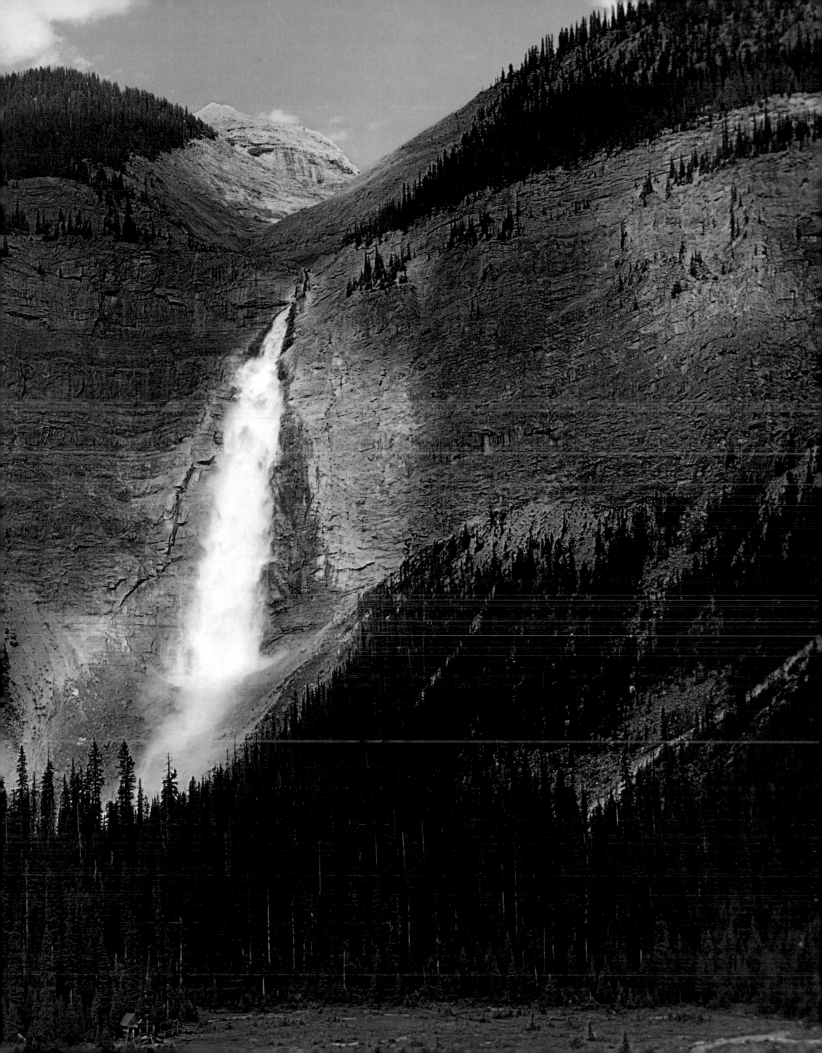

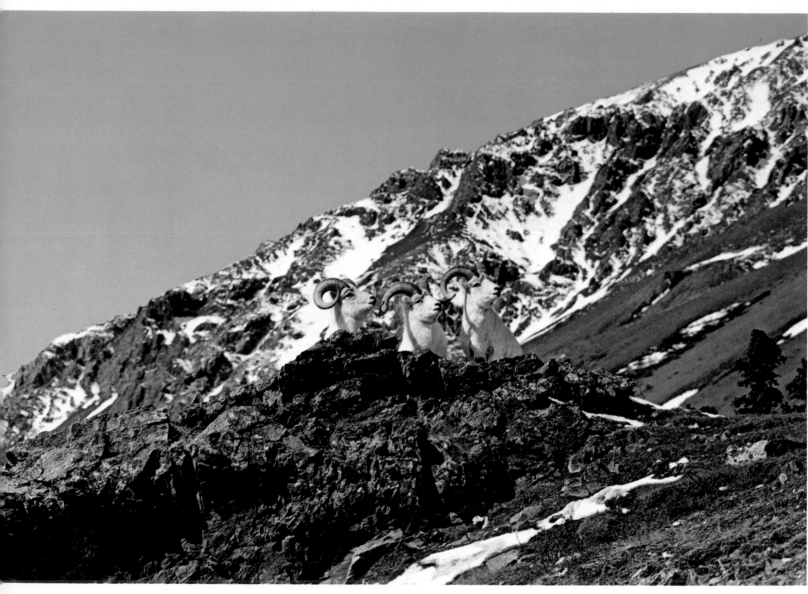

76

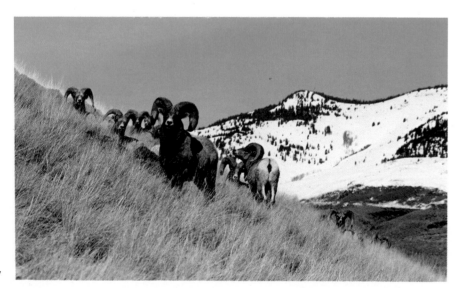

77

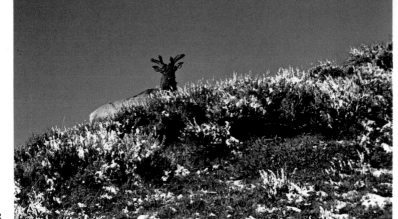

78

79

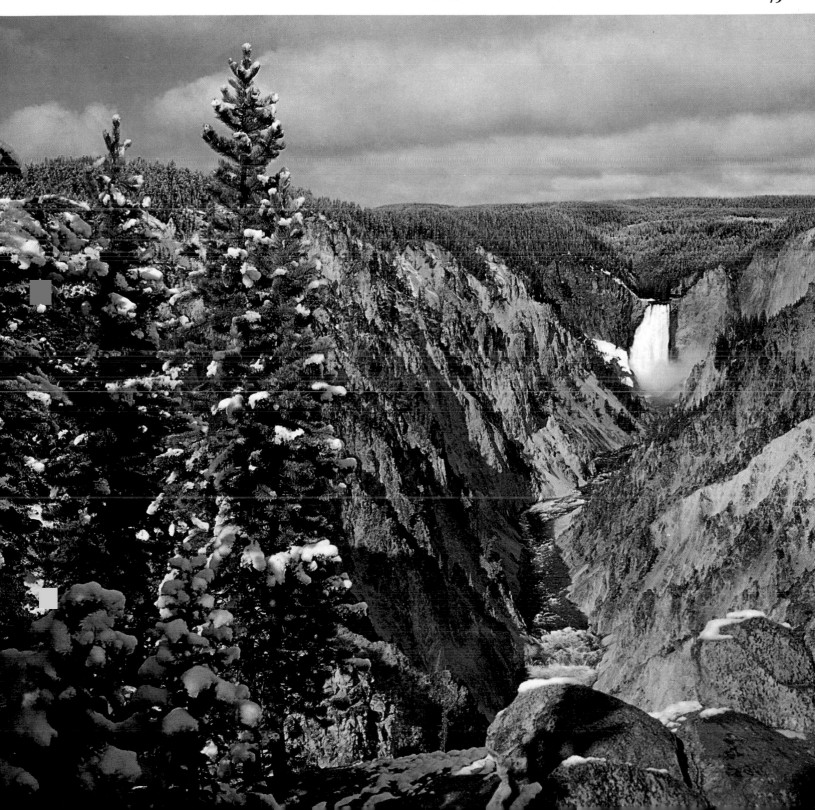

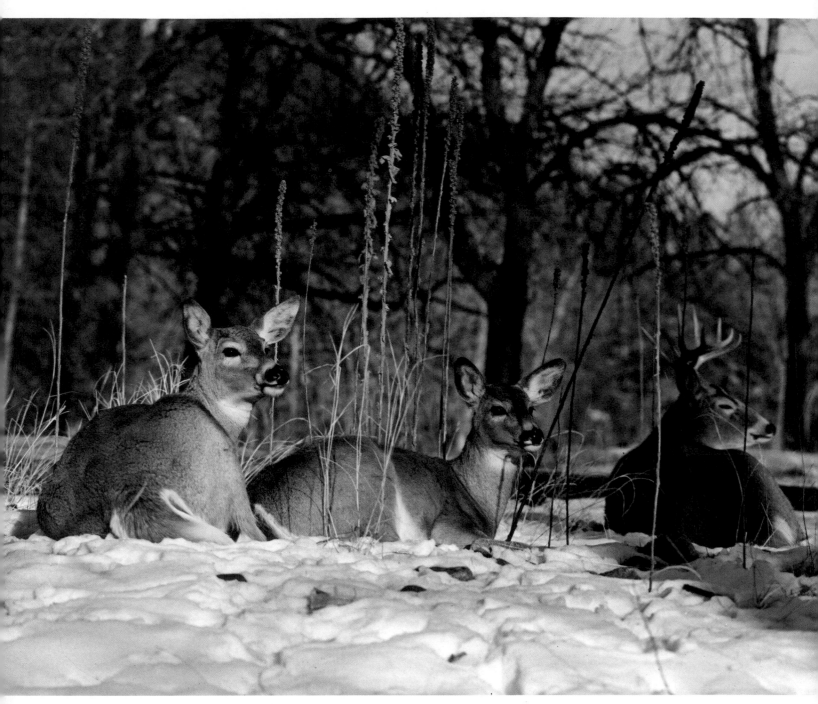

80

81

82

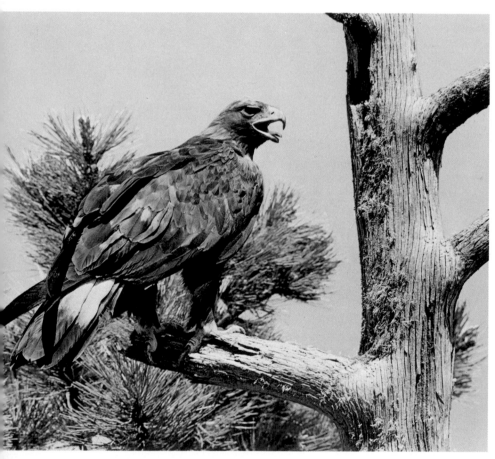

84

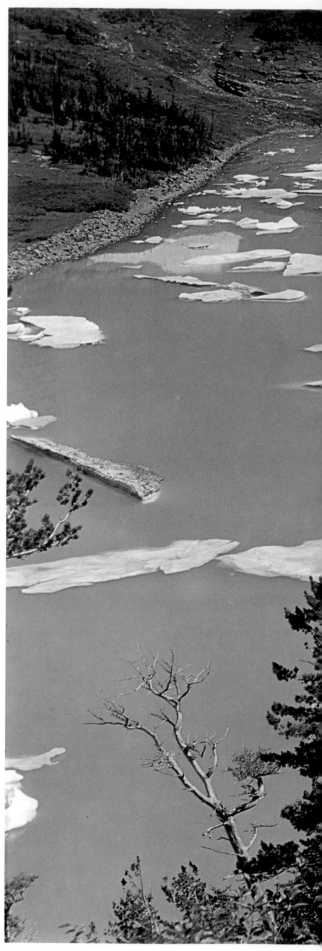

85

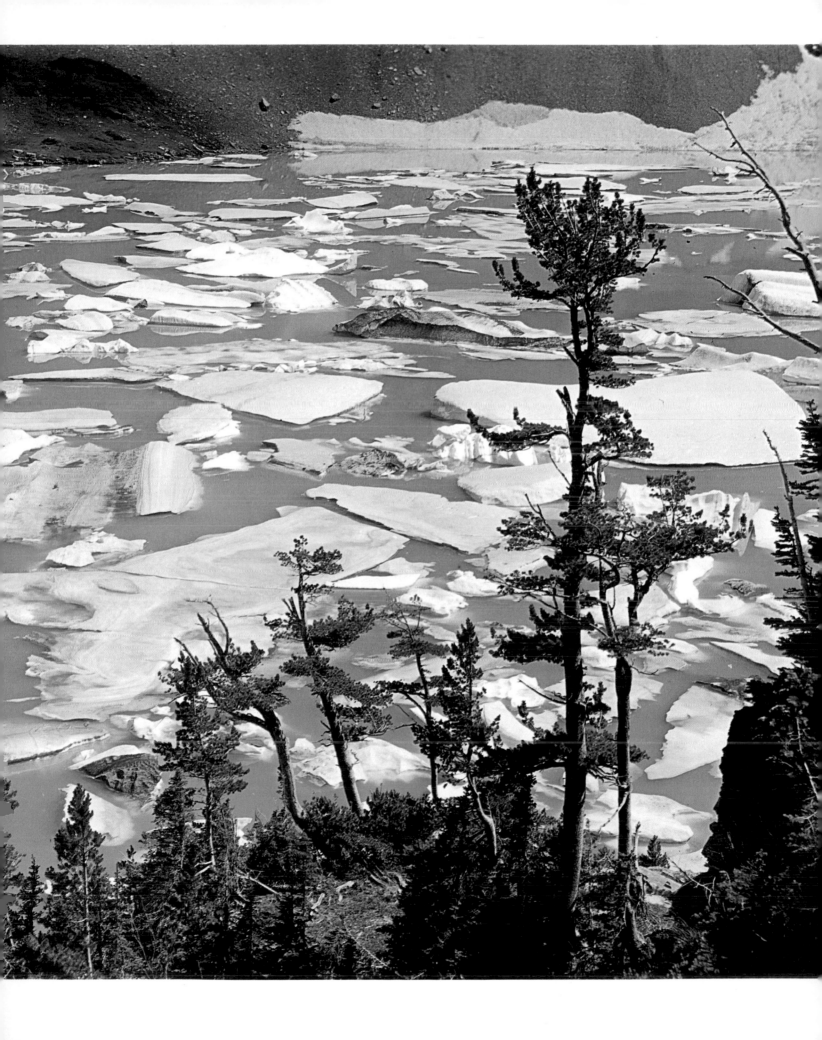

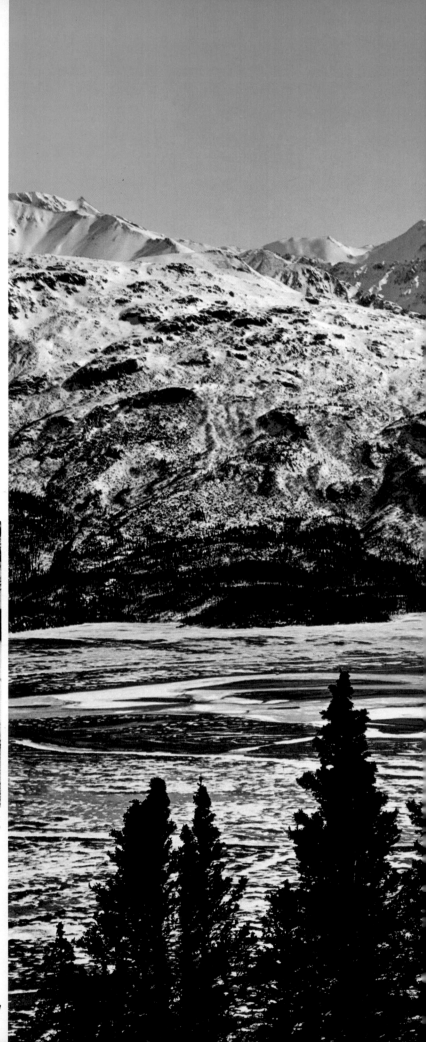

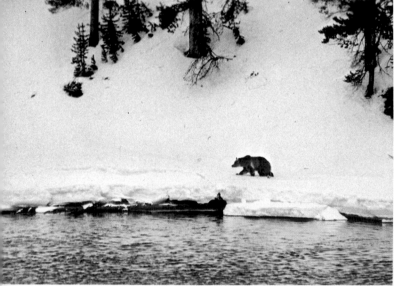

86

87

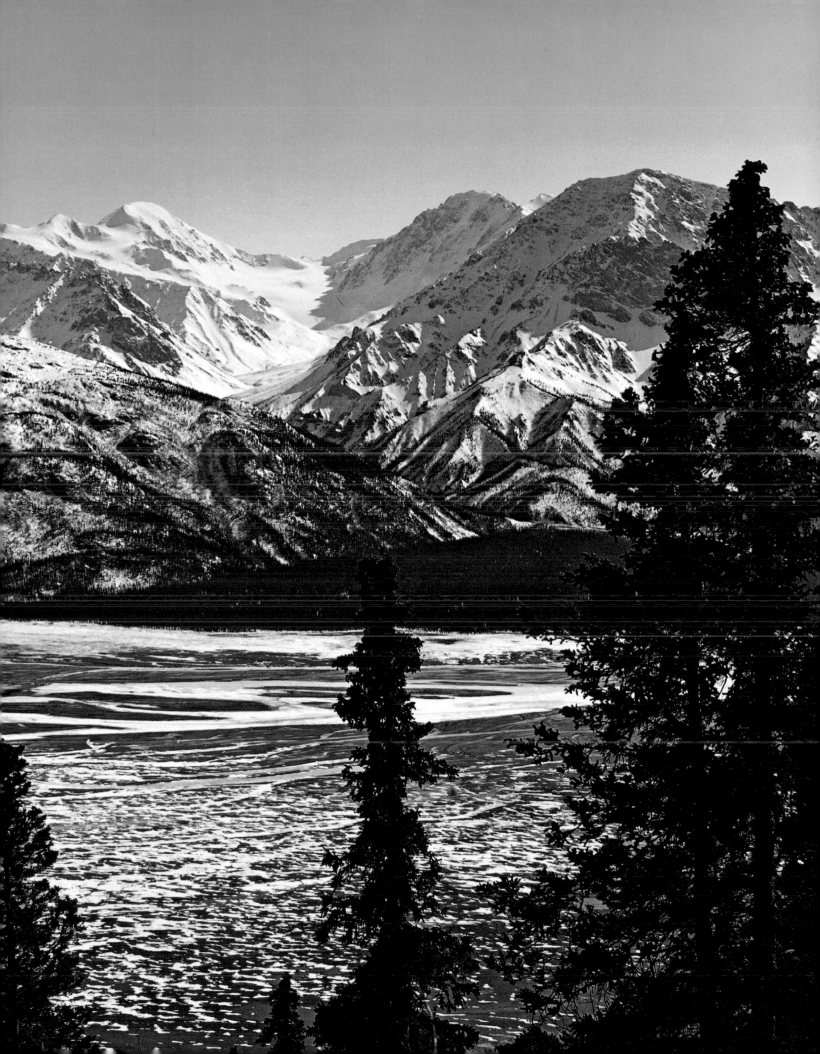

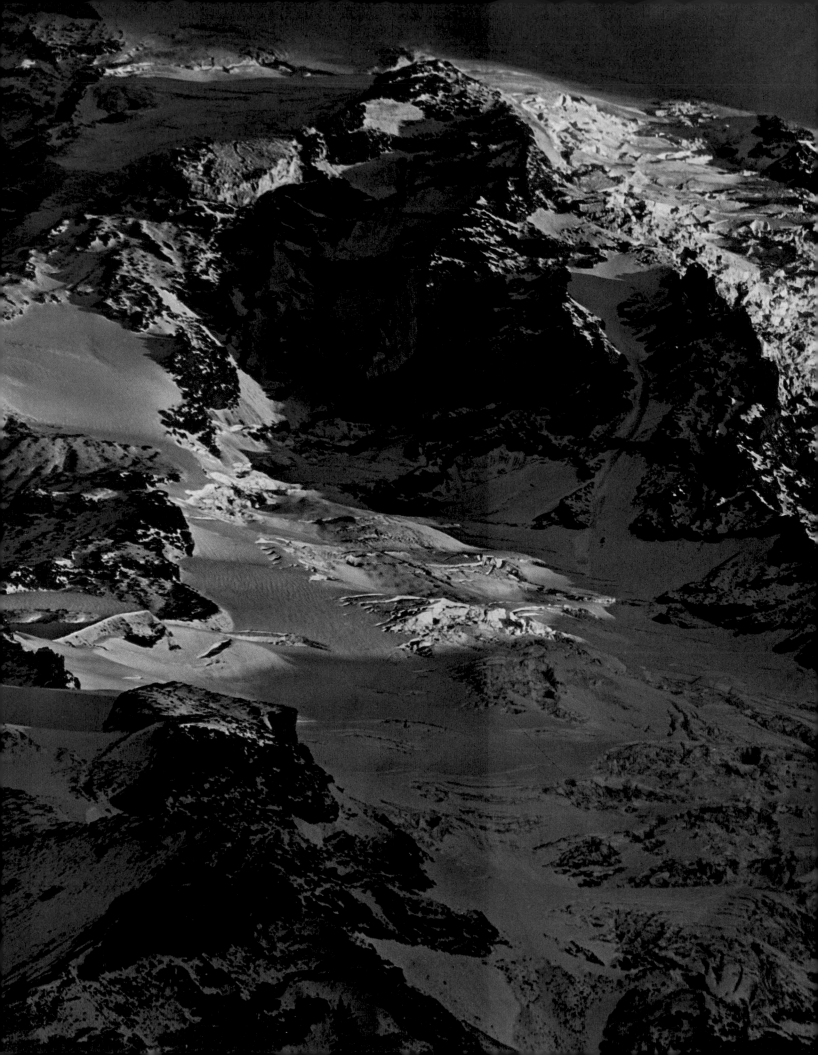

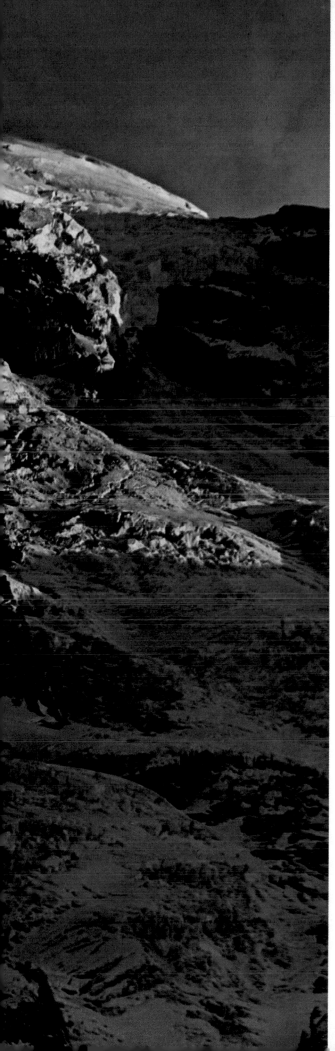

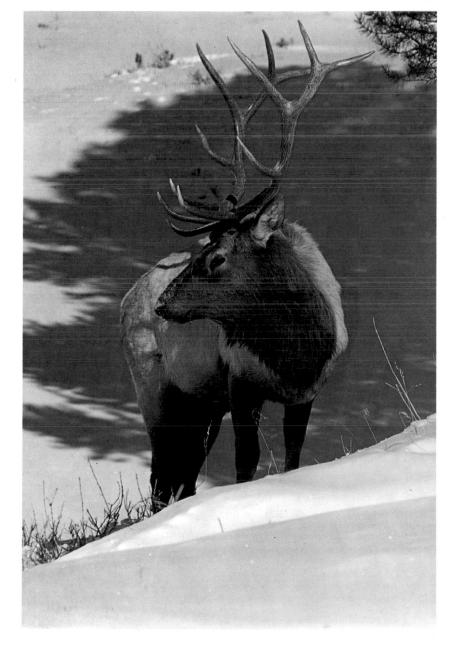

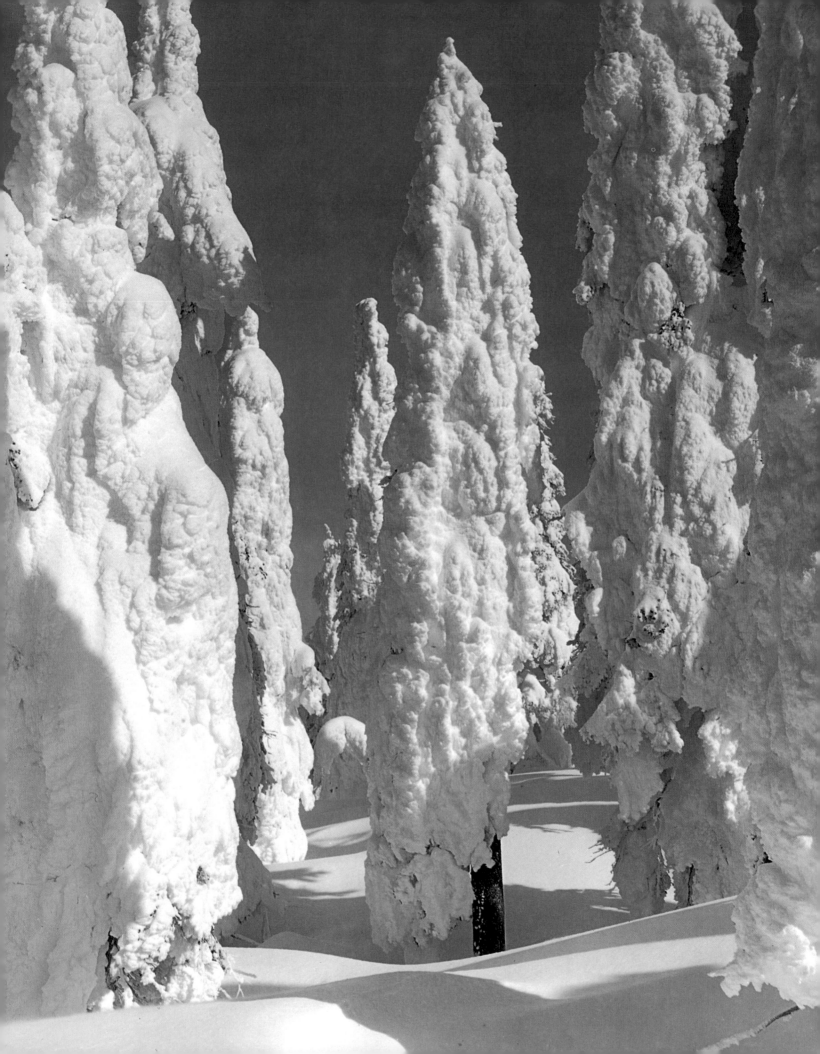

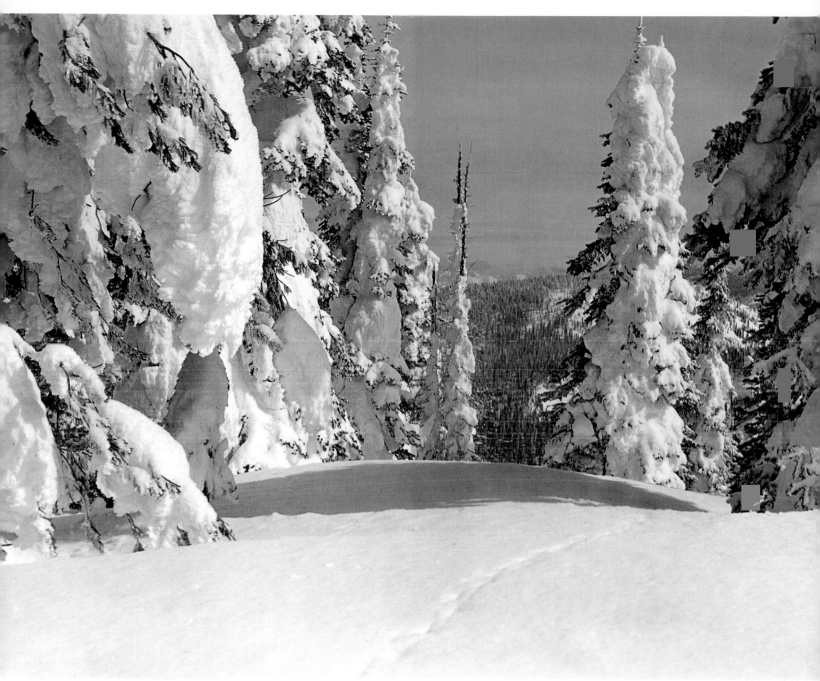

91

90

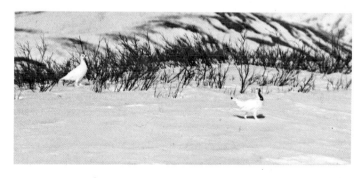

92

NOTES

NOTES ON THE PLATES

PLATE

1 Seemingly detached from earth, Washington's Mount Index is a frosted jewel on an October morning.

2 Clinging stubbornly to life, an ancient limber pine frames Fusilade Mountain in Glacier National Park. Calm now, St. Mary's Lake is a wind tunnel in winter storms.

3 The Ramparts form an awesome barrier between Alberta and British Columbia.

4 Twin mule deer fawns look out at the world from their rocky vantage point.

5 Swamp laurel takes its turn in the succession of blossoms that brighten alpine meadows.

6 Running swift and cold from high snow fields, mountain streams nevertheless nurture abundant life along their rocky courses.

7 Flowers carpet an alpine meadow.

8 A brazen camp robber, the gray jay acts so innocent about his thievery that no one seems to mind the few bits of food he takes and hides in nearby trees.

9 In bold, colossal forms nature carved a classic setting for the mountain goat. Frigid winter winds will sweep the steep slopes free of snow, so the goats can continue to graze and browse in their alpine world.

10 A jewel-like buprestid beetle is reason enough to lower one's eyes occasionally from towering mountain landscapes.

PLATE

11 Each flower species strives to outperform its predecessor in abundance and beauty. Acres of Coulter's daisy, or fleabane, bloom on a meadow that was golden with glacier lilies shortly after the snow melted.

12 Hidden among the colorful bracts, paintbrush blossoms are relatively subdued, but the plant itself is one of the showiest in the alpine meadows.

13 The high sun of midsummer reaches deep into the throat of a blue gentian.

14 As snow fields melt back, glacier lilies have their "spring," even though it may be August before some of the plants are warmed into quick growth by intense mountain sunshine.

15 The fragile bells of wild hollyhock brighten forest openings on lower slopes.

16 Like frosting on a huge cake, the raw edge of the Columbia Ice Field hangs at clifftop over the headwaters of the Sunwapta River. Downstream the river joins the Athabaska for a long and wild journey northward to the Arctic.

17 Quietly waiting for dusk and hunting time, a bobcat basks in warm afternoon sun.

18 Living in a land devoid of trees, the pronghorn depends on sharp eyes and the fastest sprint in the Western Hemisphere to avoid danger.

19 In the Pacific Northwest the mule deer has a black tail and is called the blacktail.

20 Perching on low branches, the great gray owl studies the ground below, then plummets to catch small mammals. Largest of the owls, the great gray has a five-foot wingspread.

21 Whether he's black, brown, cinnamon, tan, blond, blue, or white, this bear is still identified as a black bear. A mother bear often has cubs of different colors.

22 The sun breaking through clouds plays like a spotlight over the huge stage of the North Cascades, singling out Silver Star Mountain.

23 From shade to sun to a fall snowstorm, the influence of mountainous terrain on weather is dramatically demonstrated.

24 Fat and sleek in mid-autumn, this moose cow and calf face six months of deepening snow and extreme cold high in the Rockies.

25 Whether erosion is good or bad depends on the speed with which it takes place and the appearance of what remains. Who would undo Bryce Canyon for a forest or a field of corn?

26 Oldest of living things on earth, bristlecone pines thrive on adversity. Growing in thin, rocky soil, blasted by alpine blizzards and flying sand, plagued by drought, bristlecones as old as 4600 years are still alive.

27 More colorful than his blackish Eastern cousin, this yellow-haired porcupine was found eating succulent plants in an opening. He was easy to overtake for a few pictures, but after a slow chase he was breathing so heavily that I took pity on him and allowed him to continue at his own pace to the safety of the trees several hundred feet away.

28 Whether you call it beard lichen or wolf moss, and whether or not you know that lichens are a mutually beneficial combination of fungi and algae, the beauty of lichen-covered branches is undeniable.

29 Hundreds of small flowers are gathered in the showy heads of bear grass. They blossom every five years or so, and it is a banner year when many plants are in bloom together.

30 Largest of our waterfowl, the trumpeter swan was on the edge of extinction until complete protection and the establishment of the Red Rocks Lake Refuge in Montana turned the tide. With an eight-foot wingspread, the low-flying birds are spectacular residents of mountain lakes, ponds, and rivers.

31 From above Hart's Pass, the North Cascades seem to roll on in blue waves to infinity.

32 On drier slopes the chukar has adapted well. This Old World partridge is now a bird of the mountain West.

33 Each a giant of its kind, Mount Moran in the Tetons and a forest-antlered bull moose document the bigness of the high West.

34 Masked bandits, young raccoons are inquisitive, omnivorous, mischievous, lovable mammals.

35 The flat valley floor of Yosemite is in dramatic contrast to the steep-walled beauty all around.

36 Found only in the West, the Steller's jay adds life and color to coniferous forests.

37 Far down in the pecking order, a young bull elk is usually driven off by herdmasters if he shows interest in a harem. His fat body and neat coat show that with no herd to guard he eats regularly and wrestles only for practice.

38 Basketlike antlers and large ears identify a Rocky Mountain mule deer buck. His small white black-tipped tail differs considerably from that of his relatives in the Pacific Northwest (Plate 19), but intermediate mixtures of tail styles where the two phases have interbred show that they are all mule deer.

39 Tall, shy, and extremely well equipped to spot danger at a distance, this sandhill crane was checking out a woodland meadow as a possible nesting site, and I was able to stalk it by slithering along on my belly behind the trees.

40 Early-fall sparring of bull moose is a prelude to real tests of strength and agility as the days shorten and the temperature drops.

41 Frost and mist disappear as the rising sun warms the high country.

42 Where ton-sized bison are mere dots on the landscape, the Western perspective is awesome. The Mission Mountains in Montana are a majestic backdrop for the National Bison Range.

43 The raccoon hunts with dexterous fingers for frogs and crayfish where land and water meet.

44 Announcing that spring is here, or that winter snow is on its way, the voice of the Canada goose is a wild, free sound.

45 The trumpeter swan, a totally uncamouflaged bird, is large and strong enough to defend its nest against most predators.

46 American widgeons prefer to nest and feed in quiet backwaters where they will join in loose flocks with other dipper ducks—the mallards, pintails, and teal.

47 Friends now, but late-fall differences could drive these bull moose into frenzied battle.

48 A perfect fall day in the Rockies.

49 A frequent visitor to mountain camps, the golden-mantled ground squirrel becomes quite trusting when crumbs or nuts are offered.

50 Soft afternoon sun warms an Indian summer day in Granite Creek Valley in the Gros Ventre Range.

51 The Ramparts display shark's-tooth peaks at sunset.

52 A cold October morning creates a Christmas card setting for a bull elk.

53 Seemingly proud of their handsome racks, three bull elk parade and pose in the morning sun.

54 The little farmer of the mountains, the pika, actually cuts and cures alpine flowers and grasses, moving his haystack in under the rocks when it rains.

55 Like the howl of the timber wolf, the loon's lonely night call says "wilderness."

56 The white-tailed ptarmigan is a master of camouflage. It can disappear merely by scrunching down and remaining still.

57 Vine maple glows like a waterproof flame in a rain-soaked forest.

58 Running near the rear of the herd, a buck pronghorn moves his harem. Most experts give pronghorns credit for a sixty mph running speed, but some Westerners swear they have clocked them at seventy.

59 Pronghorn bucks, one-minded, walk over a ridge to a distant point for a reason known only to them.

60 Morning fog, hit by a sunburst, creates a frozen explosion of light.

85 Encompassed in a cirque, shaded much of the time, Iceberg Lake in Glacier National Park warms little in summer, skims anew on cold nights in late August. Large chunks of snow fields and glaciers slip into the lake from surrounding cliffs and keep it perpetually ice-filled.

86 Even when the bear is far across a river, my heart pounds when I sight a grizzly.

87 Yukon peaks above Slim's River.

88 Crevasses are formed when a glacier passes over rough ground. Severe breaking, called an icefall, occurs when a glacier is bent sharply down over a steep slope. Nisqually Glacier on Mount Rainier is glaring white and ice blue in midday, but sunrise alpenglow turns it to gold.

89 Though beautiful and graceful, an elk's antlers are designed for combat. Thrust against another bull's antlers in a strenuous and dramatic wrestling match, they are defensive as well as offensive weapons. In most matches neither winner nor loser is seriously hurt, but the winner has gained

the right to be herdmaster, and his superior strength and fitness are passed on to calves born the following spring.

90 Trees take on fanciful shapes when moist Pacific winds meet cold arctic air near the timberline.

91 It's hard to imagine how wildlife can survive where snow is fifteen feet deep, but tracks tell us that a grouse was here.

92 Whether the low, grating call of the male willow ptarmigan is a territorial challenge, a love song, or both, its musical quality is near zero to the human ear. This ptarmigan has lost some of his all-white camouflage, to enhance his mating display. When he fans his tail from under his white coat, it is a startling jet black. Come summer, both sexes will be brownish to blend with tundra foliage.

93 The Yellowstone's Lone Star Geyser in February.

L. B.

NOTES ON PHOTOGRAPHY

by Les Blacklock

Almost invariably, when I tell someone of something exciting I've seen in the wilds, the exact same seven words are spoken in reply: "Did you get a picture of it?"

And almost invariably my answer is, "No," for any of a long list of reasons. It happened too fast; I wasn't close enough; it was too dark; my camera was aimed the wrong way; the light changed and I wasn't ready. I suppose that last reason could answer many of the situations: I wasn't ready.

These answers must make a man whose career has been wildlife photography seem extremely incompetent. Most people are, of course, very polite, but I can sense their thinking. "Look, man, you mean you didn't get a *picture* of it?"

"How could a professional wildlife photographer miss so many opportunities?"

"Do you mean to say you watched an eagle attack a mountain sheep lamb and didn't photograph it?"

Mind you, they don't say these things aloud to me. But that incredulous expression is quite eloquent. It's as if my seeing a marvelous thing happen were a complete waste if I didn't record it on film.

Yet the record is undeniable. In a lifetime devoted primarily to capturing wildlife on film, I have witnessed many exciting moments that I didn't photograph.

Why? Because that's the nature of things. No wildlife photographer records a high percentage of the exciting things he or she sees. Many of these fantastic moments happen and are over within a matter of seconds. Unless you are expecting it to happen, are aimed at the spot where it's going to happen, have the right camera, lens, and film all properly set and are prefocused on the spot, there's no possible chance to do all those things while the event is taking place.

Of course you hone those odds down as much as possible. You go after a certain animal or bird where you expect it to be, and you have your equipment ready. I remember a time when I was high on the edge of a steep bank above Pelican Creek in Yellowstone National Park and my 35mm Nikkormat camera, with a 300mm lens attached, was mounted on a heavy wooden tripod aimed at some wrestling moose in the valley below. It all worked very well. I took shot after shot of the fighting bulls. This was what I'd come for, and I was ready for the action.

Then, while reloading film, I turned to see a beautiful pine marten ten feet away, standing straight as a stick, watching me at work. I have dozens of moose pictures, none of pine martens. What could I do? Nothing but admire the animal. Further movement to reload would frighten him away. Even if I were to reload and could turn the camera around without frightening him, I couldn't focus the long lens that close. So I stood awkwardly in mid-turn while he studied me for a few precious seconds, then left.

Was I frustrated? I felt a twinge, perhaps, but mostly I was thrilled to see the little marten so close, and I was very appreciative to be there at that moment.

Often a second species enters the scene I'm hoping to photograph and a whole new situation develops. On a steep mountain slope in Yukon Territory in Canada I was watching a lone yearling Dall sheep, the only creature in sight, about fifty yards away and slightly below me. A yearling is beyond the cute stage and does not yet have the majesty of a golden-horned ram, so I was not anxious to expend film on him. We were both just *there*, the lamb grazing, I standing by my big Graflex camera, hoping for the appearance of more photogenic game.

On the edge of my peripheral vision I caught movement far up the mountain. Turning my head, I saw a great golden eagle diving directly toward the lamb. Being human and humane, I had an urge to cry, ''Look out, lamb, here comes an eagle!''

But the naturalist in me forced me to watch intently and learn.

I glanced down at the lamb. He was still grazing. Back to the eagle. Wings straight out, he came like a strafing plane, his speeding shadow undulating over the steep slope ten feet beneath him. In seconds now he would reach the lamb.

A quick glance. The lamb still grazed. Like a projectile the eagle came by me. I watched entranced as he lowered his strong taloned feet. As he neared the lamb, he steepened his dive. I noticed that his feet were clenched tightly as he stooped—and missed the lamb's back by inches.

''Whew!'' I was flushed with excitement as I thought about what I had just seen, trying to stamp it as indelibly into my mind as a photograph.

Analyzing the happening, I decided that the eagle had been playing a game. Seeing the lone yearling and being in a position to streak down upon him like a falling body, but with direction, he had launched himself from a cliff high on the mountain.

Then I recalled that the lamb had merely shuddered as the eagle shot over him, and had kept right on grazing. The lamb was playing the game, too. I'm sure he saw the eagle coming as soon as I did. The bird's seven-foot wingspread shaded the whole sheep for the split second of his passage, and the ripping sound heard before the impending strike that came as the great bird sliced through the cold mountain air should have frightened anyone or any thing. And yet the yearling lamb held his ground, as if to say, ''Here comes that blankety-blank eagle again. I'll be darned if I'll let him scare me!''

I obviously had no chance to photograph that exciting drama. The 4 x 5 Graflex was set for a motion-less subject at 1/25 second. The 13-inch telephoto is only two power on the big camera. Too far away and too slow. If I *had* tried to capture it on film, I'd have been fumbling around trying to change exposures and focus and I'd have missed the whole show.

Several days later, on that same mountain, I was climbing toward an outcropping of rock where I had seen sheep beds. Not a sheep was in sight, but I had seen them daily in the area, so I climbed with some hope.

As I neared the cliffs, a fine ram peered down over the rim at me. I was in luck. I recognized the ram as one of a group I had been stalking for a week, and this time he was in a truly magnificent mountain setting. I lifted the heavy tripod and camera and set it down a foot farther up the mountain; then I slowly edged up to it. The ram watched with mild cud-chewing interest. He'd seen enough of me to be unafraid at this snail-paced approach.

Then a second ram showed up—and a third. These were the three finest heads of the group, on a cliff against a backdrop of rugged Yukon peaks. Now if they'd just hold until I could get close enough—

Hold they did. There was only one problem. Lesser rams—four, five, six, and seven—appeared. Posing at the edge of the cliff, they covered my stately rams so that I could see only bits and pieces of them. Seeing a shot of a lifetime of Dall rams dissolving in front of me, I continued my tedious open stalk: lift the tripod and place it a bit farther up the rocky slope, then move nonchalantly up to that point. For the rams, my approach was so slow that it wasn't an approach at all. I was merely another animal out there grazing.

But slow or not, I was closing the gap. I glanced up occasionally at the milling crowd. Each young ram wanted to be in front, posing as if for a cover on *National Wildlife!*

At last I was close enough. I focused and watched the action on the ground glass, trying to find something to salvage. Suddenly the young rams were gone, and my three fine rams were still there, looking down at me. I quickly checked my light meter and settings and closed the big lens down to f/22. Then I pressed down on the thumb release. Up thumped the mirror, *whump* went the curtain around the roller.

Did I remember to pull the slide? Yes.

I had a shot of three Dall rams staring at the camera, but I hoped for a further miracle—some happening to call the rams' attention away from the camera, without frightening them away.

Suddenly, as if on cue, all three heads turned and looked up the mountain. I shot, then turned to see who or what had helped me out. Far, far up the mountain a dark body moved across a hairline trail; a grizzly bear had caught each sharp eye the moment he appeared, swinging the golden-horned heads as one, and giving me the picture that I had driven 2716 miles to get.

One of my most exciting adventures took place in Pelican Creek Valley. Four bull moose were strolling toward me. They had been locking antlers far out on the willow flats, and I wanted a fight photograph that would fill the frame, so I welcomed their movement in my direction.

I had worked my way to the last lodgepole pine and was ready to climb it in case an irritable bull decided to polish his antlers on me. Closer they came, closer, and *closer*. The two bigger bulls were aimed right at me. I finally shouted, "Near enough!" I told them that if they stopped right there and had a shoving match, some editor would surely give them space.

And still they came. I was shooting with a Nikkormat, using a 300mm lens, and the image in my viewer was just eyes and ears. I glanced up to see where the lowest branch was. Twelve feet. Quite a jump, but I decided that if I missed it, I could grab it on the way down.

The big bulls finally angled a bit so they would all at least pass on the same side of the tree. I stayed on the ground and hoped for the best.

When he was only a few steps from me, the nearest bull stopped and stared at me (through me, it seemed), his ears laid back. That's one sign. Then the hair all along his back stood up, making a deep mane on his shoulders. That's another sign. Then up he rose, red-eyed and pawing the air, up, up, high above me, and came crashing down, antlers hooking—right at the other big bull!

Did I get a picture of *that* moment? You guess.

Exciting things can happen indoors, too. One cold winter night in a cabin deep in the Rockies, Ranger Tom Griffiths handed me a copy of Andy Russell's *Grizzly Country* and said, "Les, here's something I think you'll be interested in."

Interested I was, to the point that I had to be called twice for dinner. Tom let me borrow the book, and with each page I was more certain that I must contact Andy Russell at once. When I finished reading, I snowshoed to a wilderness telephone booth. The top of it came up to my knees. There was a light on inside, so I stepped off my snowshoes and slithered down through the narrow door. The phone was alive, so I gave the operator the job of finding Andy. She bounced, by wire, around the Alberta Rockies a bit before she found him via Pincher Creek, Alberta.

That phone call started the warm friendship that eventually led to our working together on this book, a record of our shared love of the wilderness.

TECHNICAL DATA

Most of the scenes and flowers were photographed with a 4 x 5 Calumet view camera and Schneider Symmar 150mm lens. On some scenes I used a 4 x 5 Speed Grafic with a 127mm Kodak Ektar lens, and on a few scenes the 4 x 5 Graflex D with a 7-inch Heliar lens.

Much of the wildlife was taken with a 4 x 5 Graflex D through a 360mm Schneider Tele-Xenar lens. Where movement and/or distance were a problem, I used a 35mm Nikkormat camera and a 300mm Nikkor-P Auto lens.

The buprestid beetle was photographed with the Calumet. The golden eagle was snapped with the Speed Grafic from a point away from the camera, using a solenoid to click the shutter. The bobcat and pika were taken with an ancient Leica and 135mm telephoto lens.

All cameras were mounted on the Professional Junior motion-picture tripod, with heavy wooden legs that provide sturdiness and steadiness.

In the 1950s and early 1960s I was using 4 x 5 Anscochrome sheet film. There is considerable representation from that period in this book. Since then I have been using 4 x 5 daylight Ektachrome and Ektachrome X 35mm film.